Heid

Heidegger Among the Sculptors

BODY, SPACE, AND THE ART OF DWELLING

Andrew J. Mitchell

STANFORD UNIVERSITY PRESS · STANFORD, CALIFORNIA

Stanford University Press
Stanford, California

This book has been published with the assistance of the College of Arts and Sciences
and James T. Laney School of Graduate Studies, Emory University.

Library of Congress Cataloging-in-Publication Data

Mitchell, Andrew J., 1970-
Heidegger among the sculptors : body, space, and the art of dwelling / Andrew J.
Mitchell.
 p. cm.
Includes bibliographical references.
ISBN 978-0-8047-7022-4 (cloth : alk. paper) -- ISBN 978-0-8047-7023-1 (pbk. : alk.
paper)
1. Heidegger, Martin, 1889-1976. 2. Sculpture, Modern--Philosophy. 3. Human body
(Philosophy) 4. Space. I. Title. B3279.H49M499 2010
193--dc22

 2010008177

Designed by Bruce Lundquist
Typeset at Stanford University Press in 9/15 Palatino with Walbaum display

A monograph for Amy

Contents

Illustrations

All sculptural works shown were either on display at the Darmstadt Ernst Barlach exhibition, to which Heidegger contributed a catalog essay, or at the Bernhard Heiliger Erker-Galerie opening, where Heidegger delivered the opening address, or, in the case of works by Chillida, they were discussed with Heidegger in conversation with Heinrich Wiegand Petzet (though in some cases it has not been possible to determine exactly which version of a work they considered). Works not appearing in any of these three contexts are marked with an asterisk (*).

Acknowledgments

A version of "Ernst Barlach: Materiality and Production" was presented at the 2009 Heidegger Circle meeting at Xavier University in Cincinnati. A portion of "Bernhard Heiliger: The Erosion of Being" was presented at the 2006 IHUM Fellows Research Colloquium at Stanford University and subsequently at the 2008 Society for Phenomenology and Existential Philosophy meeting at Duquesne University in Pittsburgh. A portion of "Eduardo Chillida: The Art of Dwelling" was presented at the Heidegger and Space symposium at Stanford University in 2007 and subsequently at the Society for Phenomenology and Existential Philosophy meeting at George Mason University in 2009. An abbreviated version of all four sections was presented at Stony Brook University in 2007. I am grateful to the organizers, respondents, and interlocutors at each of these engagements: Phaedra Bell, Andrew Benjamin, Edward S. Casey, Wayne Froman, Hans Ulrich Gumbrecht, Robert Harrison, Eduardo Mendieta, Richard Polt, Mary Rawlinson, John Sallis, Thomas Sheehan, Ingvild Torsen, Donn Welton, Laura Wittman, and David Wood. Professor Casey's own thinking of space has been an inspiration throughout.

This work would not have been possible without the cooperation of the estates and institutes preserving the work of these artists. For its completion, I am obliged to Anja Maslankowski at Ernst Barlach GmbH & Co., KG; Sabine Heiliger for her tremendous help at the Bernhard Heiliger Stiftung; Nausica Sanchez at the Museo Chillida-Leku; Elizabeth Tufts-Brown and Laurel Mitchell at the Carnegie Museum of Art; and, last but not least, the generous assistance of Urs Ullmann, manager of the Erker-Galerie in St. Gallen, Switzerland. A subvention grant from Emory University's College and Graduate School generously supplied the permission costs for the images reproduced.

In working with Chillida's texts and dealing with his estate, the assistance of Amy Alexander was invaluable. All translations from Chillida's conversation with Martín de Uglade are hers.

Emily-Jane Cohen of Stanford University Press has supported the project from the outset and I am grateful for her interest. Finally, I would like to thank Stanford's readers, Andrew Benjamin and John Sallis, for their support and encouragement.

Abbreviations

Citations of works by Martin Heidegger are given parenthetically in the text according to the following abbreviatory schema. Pagination is provided first for German editions and then, following a slash, for English where extant. Where only German pagination is given, translations are my own. Modifications to published translations are noted by a "tm" after the page reference, modifications to emphasis by an "em" after the reference.

Texts by Martin Heidegger in the *Gesamtausgabe* (Collected Edition)

GA 3 *Kant und das Problem der Metaphysik* (translated as *Kant and the Problem of Metaphysics*)

GA 4 *Erläuterungen zu Hölderlins Dichtung* (translated as *Elucidations of Hölderlin's Poetry*)

GA 5 *Holzwege* (translated as *Off the Beaten Track*)

GA 7 *Vorträge und Aufsätze* (Lectures and Essays)

GA 9 *Wegmarken* (translated as *Pathmarks*)

GA 12 *Unterwegs zur Sprache* (On the Way to Language)

GA 13 *Aus der Erfahrung des Denkens* (From the Experience of Thinking)

GA 15 *Seminare* (Seminars)

GA 16 *Reden und andere Zeugnisse eines Lebensweges* (Speeches and Other Testaments to a Life's Journey)

GA 24 *Die Grundprobleme der Phänomenologie* (translated as *The Basic Problems of Phenomenology*)

GA 26 *Metaphysische Anfangsgründe der Logik* (translated as *The Metaphysical Foundations of Logic*)

GA 45 *Grundfragen der Philosophie: Ausgewählte "Probleme" der "Logik"* (translated as *Basic Questions of Philosophy: Selected "Problems" of "Logic"*)

GA 65 *Beiträge zur Philosophie (vom Ereignis)* (translated as *Contributions to Philosophy [from Enowning]*)

GA 67 *Metaphysik und Nihilismus: 1. Die Überwindung der Metaphysik; 2. Das Wesen des Nihilismus* (Metaphysics and Nihilism: 1. The Overcoming of Metaphysics; 2. The Essence of Nihilism)

GA 79 *Bremer und Freiburger Vorträge: 1. Einblick in das was ist; 2. Grundsätze des Denkens* (Bremen and Freiburg Lectures: 1. Insight into That Which Is; 2. Basic Principles of Thinking)

Martin Heidegger in Single Editions

HK "Die Herkunft der Kunst und die Bestimmung des Denkens" (The Provenance of Art and the Determination of Thinking)

KPR *Bemerkungen zu Kunst—Plastik—Raum* (Remarks on Art—Sculpture—Space)

MLS *"Mein liebes Seelchen!" Briefe Martin Heideggers an seine Frau Elfride, 1915–1970* (translated as *Letters to His Wife, 1915–1970*)

SZ *Sein und Zeit* (translated as *Being and Time*)

Martin Heidegger in English Translation Single Editions

AS "Art and Space"

EP *The End of Philosophy*

FS *Four Seminars*

OWL *On the Way to Language*

PLT *Poetry, Language, Thought*

Other Texts

ASZ Heinrich Wiegand Petzet, *Auf einen Stern zugehen: Begegnungen und Gespräche mit Martin Heidegger, 1929–1976* (translated as *Encounters and Dialogues with Martin Heidegger, 1929–1976*)

BH Franz Larese and Jürg Janett, eds., *Bernhard Heiliger*

EB Kulturverwaltung der Stadt Darmstadt, ed., *Ernst Barlach: Dramatiker, Bildhauer, Zeichner* (Ernst Barlach: Dramatist, Sculptor, Draughtsman)

Heidegger Among the Sculptors

Introduction

A MATERIAL SPACE OF RADIANCE

Sculpture teaches us what it means to be in the world. When Heidegger turns to sculpture in the later part of his career—first somewhat tangentially in the early 1950s, then directly and in express collaboration with the sculptors themselves in the mid- to late 1960s—the encounter leads him to a rethinking of body, space, and the relation between these. A starker conception of corporeality emerges in these works, entailing a new conception of space as well. In fact, part of what is so tantalizing in these sculptural essays is the articulation of this reconstrued relationship between body and space, no longer one of the present body occupying empty space but something more participatory, collaborative, mediated, and welcoming. Bodies move past themselves, entering a space that is always receiving them to communicate and commingle in the physicality of the world. To be in this world is to be ever entering a material space of radiance.

Heidegger's sculptural reflections are born out of a rethinking of limit whereby, in keeping with a favored expression of Heidegger's, the limit marks the beginning of a thing, not its end. Things begin at their limits for it is here that they enter into relationships with the rest of the world. Thinking limit in this manner, not as a border of confinement but one of introduction, ties the thing in question indissociably to its surroundings. Thinking limit permissively, in other words, leads to a thinking of the ecstaticity of body, all bodies, simply by virtue of their appearing in a world. To appear is to be drawn out beyond oneself in a multiplicity of relations, to appear is to "radiate" throughout these relations. But this would not be possible were space not receptive to these bodies and capable of distributing their radiance, bridging their distances, making these connections and contacts across vast distances. Space must become a medium of exchange, not simply defined

1

by an absence of body. Space must be understood "materially," or rather, as no longer antipodally opposed to bodies. Only such a materially mediating thinking of space can allow the bodies to radiate beyond themselves and join in the multitudinous relationships that make up a world, a world indissociable from its spacing. Heidegger's sculptural reflections trace the contours of this material space of radiance and in so doing proceed further along a path of thought passing through both *Being and Time* and "The Origin of the Work of Art."

In the course of these later pieces, Heidegger corrects and expands upon some of his earlier analyses, not only of body and space (already no small task), but of the work of art as well. Heidegger's 1964 and 1969 engagements with the sculptors Bernhard Heiliger and Eduardo Chillida are more developed (and of greater length) than the other aesthetic interests of his later thought (most notably the paintings of Cézanne and Klee). Heidegger is also here in the position to explicitly situate the artwork in relation to the demands of a technologically dominated world. His famed analysis of technology as *Gestell* ("positionality" or "enframing") dates from 1949, over a decade after "The Origin of the Work of Art." These sculptural texts thus offer the fullest account of Heidegger's later thinking of art in its relation to technology (including extended reflection on the nature of *technē* (τέχνη) in the work of the sculptor, Greek or otherwise), and even revise the earlier "Origin" essay on one of its most guiding questions and concepts, the artwork's role in truth.[1]

Rethinking body, space, and art, these texts form a crucial stage in the work of the "late" Heidegger, and this despite the fact that Heidegger scholarship has largely neglected sustained confrontation with these texts and en-

counters, even when addressing his thinking of art and /or space.[2] These texts develop aspects of Heidegger's thinking that were otherwise left unexamined in the earlier, more familiar works such as *Being and Time* and "The Origin of the Work of Art." A brief rehearsal of the role of body and space in these earlier texts should help to better reveal the path that led Heidegger to refashion their relationship in his thinking of sculpture.

In *Being and Time*, Heidegger explores the existential nature of Dasein (literally "being there") as a being-in-the-world. This is surely a departure from the metaphysical tradition of subjectivity and the idea of a self-present subject independent of the world around it. Being "there" is written into the very term *Dasein* and with it a certain spatiality, such that being-in-the-world is "something that belongs essentially" to Dasein (*SZ* 13). But Dasein is not in the world like other objects, "its spatiality cannot signify anything like occurrence at a position in 'world space,'" Heidegger writes (*SZ* 104). A closer look at the spatiality of Dasein, however, reveals it to be surprisingly narrowly defined, a space of equipmental efficiency, ultimately unsuitable for the ecstatic corporeality of sculpture.

An issue first arises when considering the relationship between being-in-the-world and being in space.[3] When Heidegger writes that "Dasein itself has a 'Being-in-space' of its own; but this in turn is possible only *on the basis of Being-in-the-world in general*" (*SZ* 56), such a claim could be taken to suggest that spatiality is not equiprimordial with world, that being-in-the-world would underlie a subsequent entry into space. Supporting this view would be the 1928 summer lecture course *The Metaphysical Foundations of Logic*, where Heidegger not only delves deeper into the concrete nature of Dasein, but also explicitly treats of Dasein prior to its "dispersion" or "dissemination" into

factical existence. It is only due to this factical dispersion that spatiality would be of concern, for an "essential possibility of Dasein's factical dissemination is its spatiality" (GA 26: 173–74 / 138). Dasein's factical dispersal is spatial as well as bodily: "As factical, Dasein is, among other things, in each case dispersed in a body" (GA 26: 173 / 137). Both body and space arise from a dissemination into factical concretion. "Neutral" Dasein, as Heidegger refers to Dasein prior to its factical dispersal, would not know space.

Now it must be noted that Heidegger is clear even here that "Neutral Dasein is never what exists; Dasein exists in each case only in its factical concretion" (GA 26: 172 / 137), but there nonetheless remains a troubling emphasis upon a pre-individuated, prefactical, and thus prespatial, Dasein, even if only to say that the "essence" of this prefactical Dasein is always to be factical, corporeal: "The metaphysical neutrality of the human being, inmost isolated as Dasein, is not an empty abstraction from the ontic, a neither-nor; it is rather the authentic concreteness of the origin, the not-yet of factical dispersion" (GA 26: 173 / 137). There is surely room for debate on this point. Dasein's factical dispersal has been a problem for Derrida, for instance, and there are a number of ways to cast the ontic-ontological character of Dasein to avoid these appearances of bifurcation.[4] But this does not change the fact that Heidegger proceeds to think Dasein according to such a split, however propadeutic it might be: "The peculiar *neutrality* of the term 'Dasein' is essential, because the interpretation of this being must be carried out prior to every factual concretion" (GA 26: 171–72 / 136). In the later work on sculpture, this methodological conceit is abandoned in order to think the body from out of itself, space from out of itself, and not through a factical / existential divide, however nuanced this may be.

But even granting an essential spatiality to Dasein, the character of this space is still determined by factors that would otherwise inhibit what we have termed the "radiance" of worldly being that Heidegger seeks to present in his writings on sculpture. *Being and Time* details "Dasein's existential spatiality" (*SZ* 56), but insofar as the character of this space is drawn from Dasein's use of equipment (the "ready-to-hand"), it remains rather problematic.

In *Being and Time*, Heidegger argues against the primacy of a detached or isolated subject that would regard the world around it as objects of scientific observation or investigation. Instead, Dasein's fundamental being-in-the-world is a matter of explicit engagement with the things around it toward the various projects that it entertains at any given moment. Heidegger distinguishes between the modes of being that reveal themselves in these various contexts. The beings of the detached, scientific regard are the objective beings termed "present-at-hand," while the beings of use in fulfilling our projects exist as "ready-to-hand," as equipment. While the "objective" being of the present-at-hand stands over against a subject that regards it, the case is otherwise for the ready-to-hand: "What is ready-to-hand in our everyday dealings has the character of *nearness* [*Nähe*]" (*SZ* 102; tm).

The nearness in question is the nearness of our concernful dealings in the world. Dasein is futural, always engaged in projects, and these projects matter to it for its being is at issue: "Dasein, in its very Being, has this Being as an issue; and its concern discovers beforehand those regions in which some involvement is decisive" (*SZ* 104). What Dasein makes use of in carrying out these projects, the equipment as ready-to-hand, it brings near to itself (or "de-severs," to use Heidegger's term). This nearness is nothing measurable ("Every entity that is 'to hand' has a different nearness, which is not to be

ascertained by measuring distances" [*SZ* 102; tm]). The glasses at the end of one's nose, to cite a famous example, are more distant than the picture one contemplates upon the wall (see *SZ* 107). Dasein's concerns determine what comes to the fore for it, what it brings near. Nearness of this sort is more a matter of the preoccupying proximity of the objects of our concern, the ability to foreground a concern against an indifferent or less exigent background, than anything traditionally spatial.

For Dasein, this nearness is instrumentally determined: "This nearness regulates itself in terms of circumspectively 'calculative' manipulating and using" (*SZ* 102). The equipment that addresses our concerns has its place; "place is the definite 'there' or 'yonder' of an item of equipment which *belongs somewhere*" (*SZ* 102).[5] Equipment defines the places that come together to determine the "worldhood" of our world: "Space has been split up into places. . . . The 'environment' does not arrange itself in a space which has been given in advance; but its specific worldhood, in its significance, Articulates the context of involvements which belongs to some current totality of circumspectively allotted places" (*SZ* 104). As such, the "existential" spatiality of Dasein is born of its circumspective and concernful ties to the world—its equipmentality, broadly construed. Such a space is ultimately too narrow to accommodate the excessive character of embodiment found in Heidegger's later work, and this on a number of counts.

First, let us note that Dasein is, in a certain sense, at the "center" of this space, or at the very least it organizes this space around its own ends. Insofar as space arises through the equipment attending the projects of our concern and all our equipment points around to Dasein itself as its ultimate purpose, space arises with Dasein as its focus. Equipment is employed "toward" an

end, and these ends all lead back to "a 'towards-which' in which there is *no* further involvement. . . . The primary 'towards-which' is a 'for-the-sake-of-which.'" But the 'for-the-sake-of' always pertains to the Being of *Dasein*, for which, in its Being, that very Being is essentially an *issue*" (*SZ* 84). Space becomes a function of Dasein. *Being and Time* can only propose this domesticated space for Dasein.[6] Gone is the sense of being lost in space or the feeling of space's overwhelming excess. Dasein is the organizing principle of its worldhood. Only as a deprivation of this would there be "space": "Space becomes accessible only if the environment is deprived of its worldhood" (*SZ* 113).

Second, this space's origins in equipmentality are not without effect upon the quality of this space. Dasein's "existential" space is one of utility and efficiency. Nearness is governed by utility. Built for projects, this space offers no resistance to projects' achievement. What is brought close and what remains far, what rushes into the foreground or telescopes off into the background, does so effortlessly and without restriction. This space is a homogeneous field of frictionless organization of concerns, an unvariegated space of efficient functioning. It would seem that Dasein's space has the makings of an ideal, frictionless workshop.

Last, this space is eerily devoid of objects. In explaining the spatiality of objects, Heidegger considers an everyday expression like "the chair is touching the wall":

Taken strictly, "touching" is never what we are talking about in such cases, not because accurate reexamination will always eventually establish that there is a space between the chair and the wall, but because in principle the chair can never touch the wall, even if the space between them should equal to zero. If

the chair could touch the wall, this would presuppose that the wall is the sort of thing "for" which a chair would be *encounterable*. An entity present-at-hand within the world can be touched by another entity only if by its very nature the latter entity has Being-in as its own kind of Being—only if, with its Being-there [Da-sein], something like the world is already revealed to it, so that from out of that world another entity can manifest itself in touching, and thus become accessible in its Being-present-at-hand. (*SZ* 55)

Chairs do not touch the wall. They do not share the same space and are unable to encounter each other. Space does not bring any relation to them, it serves no mediating purpose. The space of Dasein is the space of the world, but as Heidegger remarks, things like chairs and walls are *"worldless* in themselves" (*SZ* 55). The things themselves do not enter space; instead our space serves to grant us unilateral access to their deployment in our projects. The mediating role of space—its communicativity and commutativity, its *reciprocity*, the ways in which space allows for relationships through separation and *varies* these relations according to the disruptions, interferences, and calmings that it suffers at the time—all this is absent from Dasein's spatiality.

The space of *Being and Time* is a Dasein-oriented space of efficiency uninfluenced by the participation of objects. With Heidegger's later turn to sculpture, gone is even the suspicion that our existence could take place or be adequately thought apart from spatiality or be considered along anything like the parameters of *Being and Time*. In these later texts space is no longer construed instrumentally; rather, technology is now seen as an assault upon space that yields the very empty space of efficiency that, in *Being and Time*, is deemed "existential." Heidegger's shift away from his earlier view of spatial-

ity is moderated by a new focus upon the work of art in the decade following *Being and Time*. In "The Origin of the Work of Art" (1936), Heidegger refines his thinking of equipmentality and embarks upon a thinking of the "work" character of the artwork. This allows him to develop the notion of shining (radiance) as well as the sense of space peculiar to it that will be so important for understanding the ecstatic corporeality of sculpture in the decades ahead.

If the space of *Being and Time* was a space defined by the tool, then "The Origin of the Work of Art" provides an opportunity for rethinking that space by reconceiving the tool. The tool is no longer simply an item of service. Serviceability and utility are now inscribed within a larger context of reliability (*Verläßlichkeit*)—"The serviceability of the equipment is, however, only the essential consequence of reliability" (*GA* 5: 20 / 15; tm)—where reliability names the tool's ability to negotiate a space beyond the control of Dasein. Heidegger's much maligned interpretation of Van Gogh's painting of peasant shoes brings to the fore the uncertainty endemic to reliability, here in the context of the peasant woman's "uncomplaining worry as to the certainty of bread, wordless joy at having once more withstood want, trembling before the impending birth, and shivering at the surrounding menace of death" (*GA* 5: 19 / 14). All of Dasein's projects are "thrown" through such a space of uncertainty. The openness of reliability keeps the tool from closing in on itself and falling into orbit around Dasein. The tool thus serves to maintain a relationship with this beyond, to manage and negotiate it. The trick of reliability is to maintain this openness to the unexpected, for this reliability relation can all too easily decay through habituation and be worn away, yielding the sense of sheer utility and serviceability that was operative in *Being and Time*: "The individual piece of equipment becomes worn out and used up. But also customary usage itself falls into

disuse, becomes ground down and merely habitual. In this way equipmental being withers away, sinks to the level of mere equipment. Such dwindling of equipmental being is the disappearance of its reliability. . . . Now nothing but sheer serviceability remains visible" (*GA* 5: 20 / 15). Reliability surpasses sheer serviceability in tending to a relationship with the unknown.

"The Origin of the Work of Art" thus reveals the closure of equipmentality to be circumscribed by an uncertain beyond. Reliability names an excess of the tool directed toward this beyond. But insofar as the tool provided Dasein with a certain worldhood in *Being and Time*, a rethinking of the tool likewise entails a rethinking of world as permeable to this excess. In "The Origin of the Work of Art," Heidegger names this excess "earth." Earth is the key to a thinking of radiance, for it is the earth that comes to "shine" in the artwork, and "world" now facilitates that shining.

Earth names an excessive and groundless phenomenality, an appearing that is untethered from an underlying substance. In the tool, this earthly "matter" is "used and used up. It disappears in serviceability. The less resistance the material puts up to being submerged in the equipmental being of the equipment the more suitable and the better it is" (*GA* 5: 32 / 24; tm). In the artwork, however, the material is allowed "to come forth for the very first time" (*GA* 5: 32 / 24). The earth then appears as an incalculable phenomenality that resists objectification, quantification, and confinement. Heaviness and color illustrate this resistance:

> The stone presses downward and manifests its heaviness. But while this heaviness weighs down on us, at the same time, it denies us any penetration into it. If we attempt such penetration by smashing the rock, then it shows us its

pieces but never anything inward, anything that has been opened up. The stone has instantly withdrawn again into the same dull weight and mass of its fragments. If we try to grasp the stone's heaviness in another way, by placing it on a pair of scales, then we bring its heaviness into the calculable form of weight. This perhaps very precise determination of the stone is a number, but the heaviness of the weight has escaped us. Color shines and wants only to shine. If we try to make it comprehensible by analyzing it into numbers of oscillations it is gone. It shows itself only when it remains undisclosed and unexplained. Earth shatters every attempt to penetrate it. It turns every merely calculational intrusion into an act of destruction. (*GA* 5: 33 / 25)

The earth disappears in contexts of equipmental utility, but comes forth to shine when removed from these utilitarian constraints. Utility seeks always what is of benefit to the subject, however that subject might be defined (as individual or as society). The goal of utility is always an appropriation of otherness for the benefit of the self-same and self-centered subject. In breaking with this, the artwork is freed from subordination to a purpose beyond itself, allowing the earth to shine out as inappropriable in a display of material beauty.

This shine of the earth radiates through "world." The world is presented as an expanse of relations, as in Heidegger's famed discussion of a Greek temple:

It is the temple work that first structures and simultaneously gathers around itself the unity of those paths and relations in which birth and death, disaster and blessing, victory and disgrace, endurance and decline acquire for the

human being the shape of its destiny. The all-governing expanse of these open relations is the world of this historical people. (*GA* 5: 27–28 / 20–21)

The expansive paths of open relation make up the world, relations no longer thought on the basis of equipment. The world stands as the medium through which the shining of earth distributes itself through relations of significance. We are subject to relationality, the relationality of the world, as long as we exist: "World is that always-nonobjectual to which we are subject as long as the paths of birth and death, blessing and curse, keep us transported into being" (*GA* 5: 30–31/23). To exist is to be transported along the lines of relation.

The shining of the earth is the shining of untethered being, uncontained, and now free to reach out to us, meaningfully (worldly). But the artwork could not issue out into these relations were there not a permissive space through which to do so. Corresponding to this conception of the worldly shining of the earth, then, Heidegger's artwork essay elaborates a nonobjective, nonutilitarian space as equi-originary with the artwork, the open clearing of "truth" (*Wahrheit*).

The relations of earth / world that issue through the work unfurl a space of appearing, or rather, they can only come forward in a space of unconcealment. Heidegger's thinking of truth begins from the Greek sense of *alētheia* (ἀλήθεια) as unconcealment (*Unverborgenheit*), where the emphasis falls not on any unitary phenomenon but on a struggle between concealment and unconcealment, "truth" naming the tension between the two. "Setting up a world and setting forth the earth, the work is the fighting of that fight in which the disclosure of beings as a whole—truth—is won" (*GA* 5: 42 / 32). The work is one way in

which truth takes place. The interplay of concealment and unconcealment is enacted across the clearing of truth. The artwork's strife between world and earth establishes it within this contested space and serves to hold it open: "In this open, therefore, there must be a being in which the openness takes its stand and achieves constancy. In taking possession of the open, the openness holds it open and supports it" (GA 5: 48 / 36).

The work is thus a delicately balanced construction that stages the tension between earth and world such that a clearing may be opened. The work, however, does not do this on its own, but can only do this when "preserved." The truth (*Wahrheit*) occurs in a preservation (*Bewahrung*) of the work whereby the work is "allowed" to be a work: "allowing the work to be a work is what we call its preservation" (GA 5: 54 / 40). The work "cannot come into being" without these preservers (GA 5: 54 / 40). The preservers allow the work to be a work by "standing within the openness of beings that happens in the work" (GA 5: 54 / 41), which is to say that the preservers do not reduce the work to something merely present (as an object for a subject) or to something merely enjoyable (as a matter for lived experience), nor do they mistake the work for a tool and allow its earthen materiality to be absorbed in service of any kind. Instead, the preservers refrain from imposing their will upon the work and allow the work to stream out in its clearing of relations. They participate in the relationships it opens, guard their persistence, and hold them open, where, as Heidegger writes "'To hold' [Halten] originally means 'to watch over' [hüten]" (GA 5: 43 / 32).

The space of the work is no mathematical, scientific, or objective space. It is likewise not thought in distinction from or in opposition to bodies, but instead as participating in the truth with them. This space of truth is itself no

empty space, but is a sheltered space guarded by the preservers of the work. It is a changed space, a medium for appearing. The work can only appear as work, in its truth, as a node of relations between earth and world, in just such a sheltered space. "The Origin of the Work of Art" thus provides for a thinking of spatial mediation that makes possible a thinking of shining and radiance.

Heidegger's engagements with sculpture in the 1960s are thus deeply enmeshed in his earlier thinking. They emerge from a rethinking of body and space that departs from the earlier conceptions of *Being and Time* and continues the trajectory of inquiry opened in "The Origin of the Work of Art," developing these latter ideas in a more explicitly corporeal vein than ever before in his work. Heidegger's texts present us with a thought of the mutual belonging together of space and body, a thought that allows the art of sculpture to touch us so.

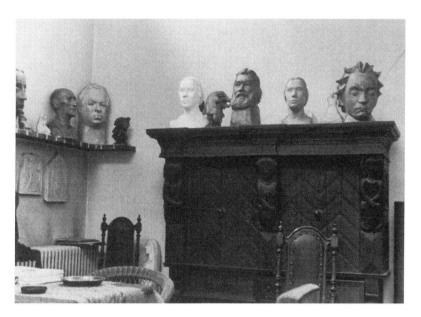

FIGURE 1.1 Ernst Barlach's Atelier in Heidberg, 1931. © Ernst Barlach GmbH & Co. KG, Ratzeburg.

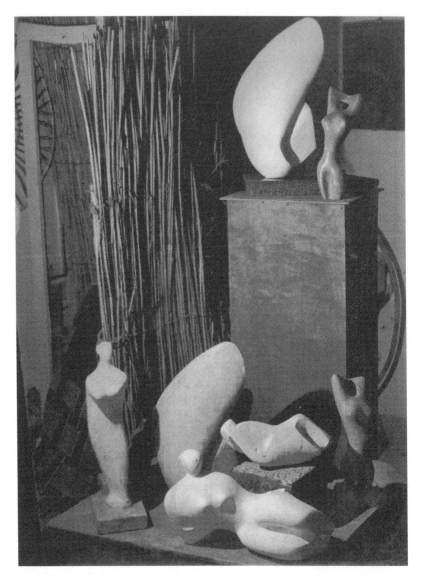

FIGURE I. 2 Bernhard Heiliger's Atelier in Berlin, 1947. Photo courtesy of the Bernhard Heiliger Stiftung. ©2009 Artists Rights Society (ARS), New York / VG Bild-Kunst, Bonn.

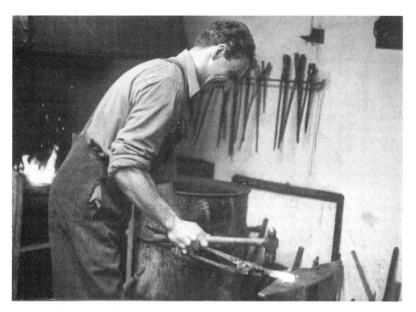

FIGURE I.3 Eduardo Chillida at his workshop in Hernani, 1951. Photo courtesy of the
Museo Chillida-Leku. © 2009 Artists Rights Society (ARS), New York / VEGAP, Madrid

Does the infinite space we dissolve into, taste of us then?—*Rainer Maria Rilke*

As a form of making, indeed often as its exemplary case, sculpture is determined by an ontology of production that Heidegger dates back to medieval and ultimately ancient Greek sources. The distinction between essence and existence that will dominate medieval and modern ontology takes its start from the paradigm case of a craftsperson at work in the production of an artifact, where what is produced is brought into existence in accordance with a prior vision of what it should be. God, too, is thought on this basis. God is God the creator, producer of the *ens creatum*, the creature. In Heidegger's 1927 lecture course *The Basic Problems of Phenomenology*, this God as *ens increatum* is a sculptor: "God is regarded as a sculptor and specifically as the prototypical modeler of all things who needs nothing given to him beforehand and therefore also is not determined by receptivity" (*GA* 24: 214–15 / 151). In this same text, Heidegger emphasizes how this sculptural model of production understands things as self-enclosed and discrete in essence:

> The look, εἶδος [*eidos*], and the form, μορφή [*morphē*], each encloses within itself that which belongs to a thing. As enclosing it, it constitutes the limiting boundary of what determines the thing as finished, complete. The look, as enclosing the belongingness of all the real determinations, is also conceived of as constituting the finishedness, the completedness, of a being. . . . This boundedness of the thing, which is distinctively characterized by its finishedness, is at the same time the possible object for an expressly embracing delimitation of the thing, for the ὁρισμός [*horismos*], the definition, the concept that comprehends the boundaries containing the reality of what has been formed. (*GA* 24: 152 / 108)

God the sculptor produces finished beings and this notion of finishedness attends the conception of the present-at-hand in *Being and Time*. Heidegger returns to consider production in his later work as well, most acutely in regards to Marxism. According to the Marxist view of existence, Heidegger writes, the human "understands himself and acts as the producer of all 'reality'" (*GA* 15: 389 /*FS* 74). Accordingly, for Heidegger, the emphasis upon production leads to a completely subjectivist reality, where what exists does so owing to the work of the human. The human produces everything, including the human itself. Production thus participates in what Heidegger terms a metaphysics of the will to will, the "position of the most extreme nihilism" (*GA* 15: 393 /*FS* 77).

Despite the nihilism of Marxism, the present-at-hand finishedness of the *ens creatum*, and the connection of these with a form of production exemplified by the sculptor, Heidegger returns to considerations of sculpture in his work of the 1950s and 1960s. And while in these writings and lectures dedicated to the work of sculptors Ernst Barlach (1870–1938), Bernhard Heiliger (1915–95), and Eduardo Chillida (1924–2002), Heidegger emphasizes the nihilistic world of industrial technology confronting the sculptor (Barlach), he nonetheless also articulates a positive conception of sculpture as evincing a spatiality no longer determined by the oppositions of metaphysics, be it those of presence / absence or of the sensible /supersensible. Considerations of sculpture in the 1960s provide Heidegger with the opportunity for a thinking of sculpture as harboring a concealment that opens a new relational space (Heiliger), a space no longer conceivable as empty but instead as already a preparation for human dwelling (Chillida).

1

Ernst Barlach

MATERIALITY AND PRODUCTION

Articulation 1: Degeneracy

The great German expressionist and antiwar sculptor Ernst Barlach enjoyed increasing popularity after the First World War, only to suffer its loss with the National Socialist rise to power. His less than finished forms were at odds with the Nazi ideology of realistic (and totally realized) formation, and his "primitivism" drew the ire of party officials. Hundreds of his works were subsequently removed from display, confiscated, and destroyed. As early as 1934, the head of the Nazi Party in Mecklenburg, Friedrich Hildebrandt, argued in a party rally keynote address that "the artist's guild has the duty to comprehend the German in his simple honesty, as God created him," that is, as complete and finished in form. "Ernst Barlach may be an artist," he continued, "but German nature is alien to him."[1] Tellingly enough, a year later a volume of Barlach's drawings was banned by the Reichsbeauftragter für Formgebung (literally, the Reich's Commissioner for Bestowal of Form).[2] And in 1937, cementing his reputation as "degenerate," Barlach's work was included in the infamous *Entartete Kunst* (Degenerate Art) exhibit in Munich. Hounded by the Nazis and driven into isolation, Barlach died of heart failure in 1938.[3]

When Egon Vietta edited the catalog for a 1951 retrospective exhibition of Barlach's sculptures and drawings in Darmstadt, he asked Heidegger for a contribution.[4] Controversy still lingered around Barlach, and the 1951 Darmstadt exhibition was by no means guaranteed an approving reception.[5] Heidegger complied and "The Abandonment of Being and Errancy," Heidegger's first publication to explicitly address the Second World War, appeared in the catalog. In it, Heidegger offers his most vitriolic assessment of contemporary life in a state dominated by technology and National Socialism.[6] Heidegger's remarks on the impotence of all leaders (*Führer*), the metaphysical inseparability

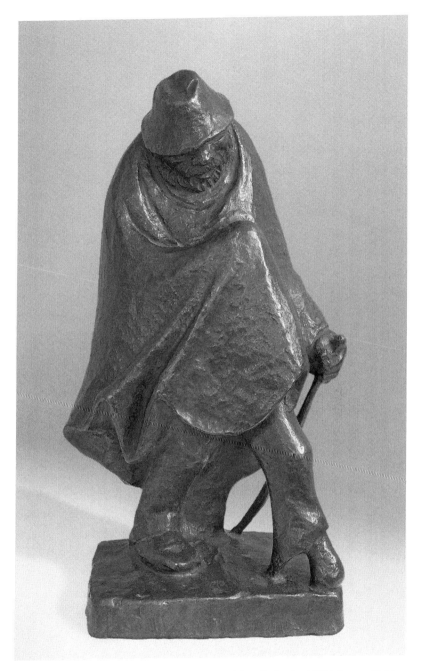

FIGURE 1.1 Ernst Barlach, *Das vergnügte Einbein* (The Jolly Peg-Leg), 1934. Bronze, 54 cm.
© Ernst Barlach GmbH & Co. KG, Ratzeburg.

between the superhuman (*Übermensch*) and the subhuman (*Untermensch*), and the science behind planned breeding, philosophically contextualize the plight of this sculptor who died under Nazi scrutiny. As Vietta writes in introducing the piece, "We publish this contribution because we believe ourselves to see a hidden connection between the inclinations of the dramaturge Ernst Barlach and the thinker Martin Heidegger. 'Where, however, there is danger, the saving power also grows' (Hölderlin)" (*EB* 5). While Heidegger does not explicitly discuss Barlach in his piece, the "hidden connection" between the two (between Heidegger and the *sculptor* Barlach) hangs on an understanding of what Heidegger terms the "abandonment" of being. The abandonment of being presents a vision of beings as harboring a constitutive insufficiency that surrenders them wholly to the world, an insufficiency embodied in the plastic works of Barlach.[7]

Abandonment is a way to think being as neither wholly present (it has abandoned beings) nor wholly absent (abandonment is *noted*, it leaves its mark on beings). Beings bear the abandonment of being, and it is only in—or *as*—beings that abandonment is found (abandonment is never without a trace). Abandonment of being should not be thought as separate from the beings, but as a relation that stretches beings into the world to the point of their dissolution. Abandoned beings are not without being, nor is being somehow absent in abandonment. Instead, abandonment names the way in which the being appears in an inextricable relation with beings. What the abandonment of being names, in other words, is a way of experiencing beings such that they are no longer construed as self-contained and discrete objects but as already opened and spilled into the world. Being lies beyond the being, calling out to it that it come forth. The idea of an abandonment of being keeps us from imag-

ining being as inhering in the thing; it names the way in which the particular being is always stretched into a context as essentially relational. This "worldly" manner of existence has consistently been overlooked (forgotten) across the history of philosophy, from the objects of modern philosophy (moments of presence in a void of absence), to the circulation and replacement of modern technology's standing reserve (*Bestand*). Being takes place *between* presence and absence, at the surface where the being extends beyond itself and enters the world. Being takes place at the limit of the thing—understanding limit as Heidegger does, not as where something ends but where it begins.

In Barlach's sculptures the sharp defining boundary is blurred. The tension between articulation and ground figures prominently. The only surfaces of distinction are the chiseled faces and finely hewn hands or feet, the extremities of the body. They often seem the culminating blossoms of an emergent material gesture. The indistinct matter in Barlach's sculpture fails to achieve the full determination and stamping of form requisite for classificatory certainty. Barlach's figures ultimately *are* degenerate, but they are degenerate in an unworking of the generative power of the creator, sculptor god. The degenerate forms of Barlach no longer display the finishedness and distinction of the *ens creatum*. In a letter addressing the biblical account of God's six days of creation and seventh day of rest, Barlach writes against the ideal of finished creation, "But I fear that that Sunday was followed by a hungover Monday and a new week's labor; and so it continues until today; in short, creation has no end, and ultimately creator and creation are one."[8]

Production Without End

Contemporary production is determined by a drive to production that is impossible to satisfy. Production today is limitless production or production without end. Heidegger reads contemporary society as determined by a Nietzschean will to power, augmented in its scope and focus by an ever advancing technology. The Nietzschean response to a void is creation, that is, proliferation and profusion. These voids prod life further. Nietzschean overcoming requires these encounters with the void as the achieving of one's own limits, in order for the creative act that oversteps these limits to assert itself and utter its holy yes. The will to power secures its own position while simultaneously increasing its domain of control in subsequent acts of appropriation and self-overcoming. In this way it creates order out of the void, out of what Heidegger calls the "emptiness" of being (*GA* 7: 94 / *EP* 107). When production becomes a matter of life or death, when everything is at the disposal of and serves production (when everything is "mobilized," to use the language of Ernst Jünger), when production is all-consuming, it becomes consumption, everything is consumed for production:

> The consumption of all materials . . . for the unconditional possibility of the production of everything is determined in a concealed way by the complete emptiness in which beings, the materials of what is real, are suspended. This emptiness has to be filled up. But since the emptiness of Being can never be filled up by the fullness of beings, especially when this emptiness cannot be experienced as such, the only escape from this emptiness that remains is the incessant arranging of beings in line with the constant possibility of an ordering that takes the form of a securing of aimless activity. (*GA* 7: 94 / *EP* 106–7; tm)

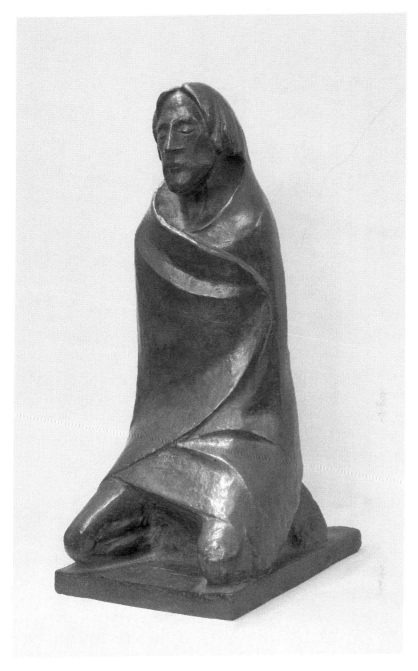

FIGURE 1.2 Ernst Barlach, *Der Asket [Der Beter]* (The Ascetic [Praying Man]), 1925.
Bronze, 70 cm. © Ernst Barlach GmbH & Co. KG, Ratzeburg.

Emptiness is required so that there might be space into which we could over-step the given. Emptiness in this sense is a condition of growth, the space we would grow into in a Nietzschean movement of self-overcoming in the face of this void. Expansion requires room to grow. But emptiness likewise determines the consumption of all materials, it *needs* to be filled. This need arises as a result of the putting into play of the opposition between presence and absence. A strange logic operates at the root of metaphysical oppositions, for in the antagonistic division of terms, each is defined against the other, but at the same time proffered as independent and distinct. For the distinction to hold cleanly, without contamination, the terms must no longer need each other. And this can only lead to the destruction of one by the other, as one can never prove itself "pure" enough (and to share the same space with the op-ponent is already compromising). The onset of metaphysical oppositions cul-minates in the vigorous conflict and eventual collapse of these oppositions (the privilege that Nietzsche holds for Heidegger is rooted in his collapsing of the inaugural oppositions of Platonic metaphysics).[9] For this reason, then, emptiness requires filling up and determines the consumption of beings that seeks to fill it up.

But the abandoned character of beings, their inherent openness and insuf-ficiency, keeps them from filling up this space like so many bricks in a wall. Instead, in an era of high technology, growth culminates in the arranging of networks for the ordering and delivery of goods, whereby the emptiness is masked by supply chains and circulatory networks that strive toward omni-presence. The circulating beings, too, are no longer pieces of modernist objec-tive presence, but completely beholden to these networks for their existence (they are part of the standing reserve [*Bestand*], though it does anything but

stand). In this way, the will continues. The will has no other goal than to create conditions that will allow it to will further, ultimately to will only itself insofar as what it wills is the appropriation of what is other (to will that it become stronger). As such, its activity is "aimless," striving for nothing outside or apart from itself.

The maximization of production through these networks of circulation includes ultimately the production of not only replaceable objects but objects that are already en route to replacement. To exist within these networks is to be diffused along their paths, to be everywhere at once and nowhere ever wholly. What is present here is likewise present in a storeroom awaiting the call for delivery, already on its way to delivery, surging along the circuitry. In such conditions, the apotheosis of production is attained. Production spurs production, as it produces only the ersatz and no longer the thing itself: "The 'substitute' and the mass production of ersatz things is not a temporary device, but the only possible form in which the will to will, the 'all-inclusive' guarantee of the planning of order, keeps itself going and can thus be 'itself' as the 'subject' of everything" (GA 7: 94 / EP 107). The finishedness of medieval production is overcome in the limitless production of the ersatz.

Earthly Ambiguity

A recurrent theme in the Nazi denigration of Barlach was the earthbound character of his sculptures. A 1932 issue of the party newspaper *Völkische Beobachter* (People's Observer) attacks the idea of Barlach as a Nordic or even Christian artist in just these terms. Instead, the author writes, Barlach's sculptures evince an Eastern character: "Barlach shapes the Russian person, sometimes even the subhuman, in his full bondage to the earth and dullness. His humans, even when they sway or hurry or move themselves hastily, are all so horribly heavy, they cling to the ground, to the everyday, they are not at all capable of once raising themselves above it."[10] Alfred Rosenberg continues the thought a year later in a Munich newspaper, when, after praising Barlach's technique, he writes, "But what he shapes of humans is foreign, utterly foreign: earth-enslaved massiveness and joy at the impact of heaviness and the material."[11]

The National Socialist objection to the earthen nature of Barlach's work is an objection to its unformed massiveness. The earth stands for material that has yet to be taken up and spiritualized. This spiritualization is an assumption of meaning on the unformed and meaningless. Meaning is marking, forming, and the bestowal of meaning is life itself. The healthy life is one that grows ever more definite and meaningful in a meaningful world, growing into the full realization of its purpose. The healthy individual is a productive member of the state.

The idea of endless production ultimately says nothing other than this. When production achieves "endlessness," it becomes indistinguishable from consumption. Everything is enlisted or mobilized in the production process and consumed for its ends. Even at the level of the particular thing, all of it

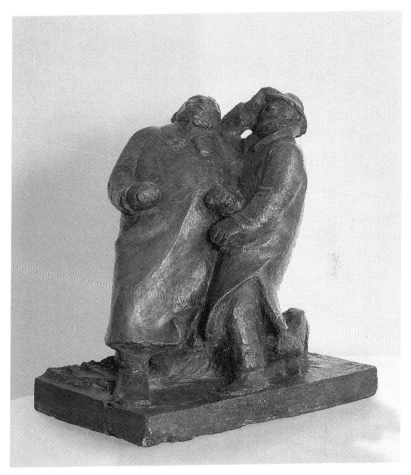

FIGURE 1.3 Ernst Barlach, *Panischer Erschrecken* (Panicked Terror), 1912. Bronze, 45 cm. ©
Ernst Barlach GmbH & Co. KG, Ratzeburg.

must be completely given over to the purpose of mobilization (mobilization would not be "total" without this). Every bit of the thing must be deployed and used, which is to say marked and determined in its destination, registered into production. This is the health of the economy and of the body.

Examining the work of National Socialist–approved sculptors like Arno Breker or Josef Thorak confirms the meaning of health to be the bearing of meaning, and this is expressed in two ways.[12] First, their bodies typically possess an unusually detailed articulation of the musculature (chiseled abdomens seem a specialty). No part of the form is left untouched, all is worked over by the sculptor to make present a body that itself reflects an utter infusion of will and discipline. The meaning of the body is in its finely muscled articulation. Or a second tact is taken and the bodies give up some of their detailing to achieve a higher symbolic value. They lose the minutiae of musculature for a suffusion of allegorical meaning. They are giant characters in the alphabet of the state, enlisted to convey the meaning of vitality, nobility, contest, life. They surrender their muscle for this other form of overdetermination.[13]

Not so Barlach. His earthy figures are glaringly undefined, comfortably reposed in their inarticulate massiveness. Rather than bear a preconfigured, self-asserted meaning, rather than wear the uniform of the state to stand at the ready, they fail at such univocity, finding their meaning in relation to the indeterminate. Barlach's sculptures await the determination of a God in prayer. They hold themselves back from terrible sights in panic. But at the same time that they pull their faces away, or lower their gaze in prayer, they thrust their earthy bulk forward, offering it up to contact and touch. Barlach's figures surrender their self-assertion, take off the armor of determination, and stand naked before us, clothed in the indeterminacy of earthly life.

In the notebooks concurrent with "The Abandonment of Being and Errancy," approximately one year after the "Degenerate Art" exhibition and the inauguration of the annual "Great German Art Exhibition" of National Socialist–approved art in Munich, Heidegger comments on the contemporary art scene: "What still counts as 'art' today, be it 'good' or 'bad,' we must take like those shriveled leaves, lifeless and fallen away from the force of the roots, that are whirled about by the wind and thus show signs of a 'movement' that simulates life" (*GA* 67: 108). Full determination is death, not life, we might say. Heidegger's condemnation speaks from a perspective of life as did the National Socialists. But life differs. Life is never life.

Barlach, the sculptor reviled as un-German by the National Socialists, is thoroughly concerned with his belonging to the soil of the homeland. A 1937 text by Barlach, first published in 1949, entitled "As I Was Threatened with a Ban on Exercising My Profession," states: "I feel with my increasing years ever more an indissoluble bond with the soil of the homeland. I know, that I only belong there where I hitherto have worked and lived, and since one slanders me as being foreign, I proclaim a better, stronger, and thoroughly deeper native belonging, a belonging formed more out of history and experience, indeed a hearkening to my birth land."[14] Barlach and the National Socialists speak of homeland. But the homeland differs. Homeland is never homeland.

It was just such ambiguities that the Nazis abhorred. Against a standard of total definition, they called it "degeneracy." But "generosity" is the better name, the bodily offering of earthly existence—indeterminacy as a giving to the other.

Human Materiality

What seems to horrify Heidegger with regard to modern technology (and this seems to mark a change in emphasis between his views on technology or machination [*Machenschaft*] before and after the onset of the war) is the way in which technological transformations have laid claim to the human and transformed that human into a "raw material" (*GA* 7: 91 /*EP* 104). A few years prior to the Barlach retrospective, in a lecture attended by Vietta ("the boldest statement of his thinking," Vietta reported),[15] Heidegger had carried this transformation to its gruesome conclusion in the claim that those who die in the "annihilation camps" become "pieces of stock in the standing reserve of a production of corpses" (*GA* 79: 56). For Heidegger this is effectively the end of all humans once the human has been transformed into raw material, whether some of those humans assumes the mantle of "leaders" (*Führer*) of the planning or not, and whether the human be distinguished as the "most important raw material" or not. With regard to these supposed leaders, Heidegger writes, "One believes that the leaders had presumed everything of their own accord in the blind rage of a selfish egotism and arranged everything in accordance with their own self-seeking. In truth, however, they are the necessary consequence of the fact that beings have crossed over into the way of errancy, in which that emptiness spreads which requires a single ordering and securing of beings" (*GA* 7: 92 /*EP* 105; tm). These leaders are the supposed superhumanity (*Übermenschentum*) that remain discordantly opposed to subhumanity (*Untermenschentum*), where, in adherence to the antagonistic division rending the *animal rationale*, "the drive of animality and the *ratio* of humanity become identical" (*GA* 7: 93 /*EP* 106). Despite appearances, the human cum consumer holds no special place in the cycle of consumption: "The human is the 'most important

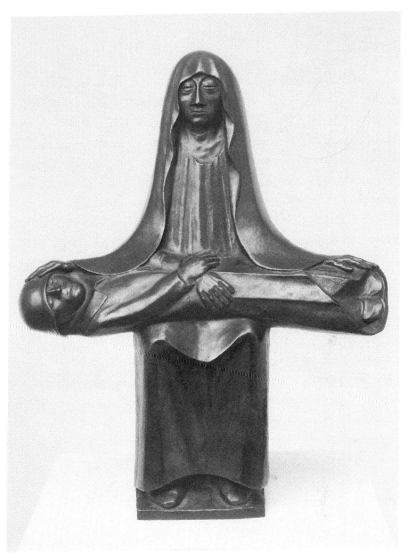

FIGURE 1.4 Ernst Barlach, *Pietà*, 1932. Bronze, 64.5 cm. © Ernst Barlach GmbH & Co. KG, Ratzeburg.

raw material' because he remains the subject of all consumption, so much so, that he lets his will run unchecked in this process and thereby becomes at the same time the 'object' of the abandonment of being" (GA 7: 91 / EP 104; tm). The drive to have everything available for instant consumption equally renders the human a commodity. This is nowhere more evident than in the fields of biochemistry and biotechnology already burgeoning in Heidegger's time, where the human becomes increasingly something on demand and at our disposal: "Since man is the most important raw material, one can reckon with the fact that some day factories will be built for the artificial breeding of human material, based on present-day chemical research" (GA 7: 93 / EP 106). Heidegger cites the research of the chemist Richard Kuhn as facilitating even "the possibility for the production of male and female creatures in accordance with a plan and directed according to demand [Bedarf]" (GA 7: 93 / EP 106; tm).[16]

But what can Barlach's sculpture tell us about this? Why is Vietta convinced that Heidegger bears a "hidden connection" to Barlach? Does Barlach have anything to say about planned breeding or the abandonment of being? Certainly not, and nevertheless his sculptures reveal almost nothing else. The simple and undifferentiated masses from which his sculptures emerge disclose portions of the individual that have not yet achieved a formal definition. They reveal that articulation occurs only against this ground, with humans often nestled within indeterminate masses or smoothly arising out of them. Articulation in Barlach's sculpture occurs at those places where we contact the world (head, feet, and hands), but this articulation never reaches so far as to bring the whole of the human into focus or to make that whole of the human available to us. Instead, Barlach allows the emptiness of formation to remain alongside determination, the articulated alongside the unused.

Viewing Barlach's sculpture in light of Heidegger's essay reveals the extent to which all his work is an act of resistance against the National Socialist drive to form—not, however, by simply asserting the opposite and championing a vague formlessness, but by revealing the limits of form as a contour of reciprocity with the raw matter that lies beyond it. Paradoxically enough, Barlach's sculptures are more formed than any Nazi body could be, precisely through his refusal to reify or crystallize form and extract it from its enabling conditions.[17] Barlach's sculptures are consequently exposed in ways that the extreme definition or formal purity of Nazi sculpture can never be. As Barlach himself states, his basic theme has always been "the human situation in its nakedness between heaven and earth [in ihrer Blöße zwischen Himmel und Erde]."[18] Barlach's works do not forego definition but they do not hypostasize it either. They provide a hint for thinking embodiment and resistance in a world dominated by endless production. Barlach's sculptures suggest that definition is always contextual and the thing defined always includes as its essence even the undifferentiated space around it. Barlach's work embodies the relationality of form, the same relationality made possible by the abandonment of being, and it is precisely these aspects of form and embodiment that Heidegger develops in his thinking on sculpture in subsequent years.

2

Bernhard Heiliger

THE EROSION OF BEING

Public Art: Contra Documenta

Heidegger encountered the sculptor Bernhard Heiliger at the prime of the artist's career, with works by Heiliger having been displayed at the first three international Documenta exhibitions (1955, 1959, 1964) and a number of large-scale public works recently installed in Germany and abroad.[1] In a speech entitled "Remarks on Art—Sculpture—Space," delivered at the opening of Heiliger's solo show at the Erker-Galerie in 1964, two days before the close of Documenta III, Heidegger presented sculpture as a confrontation whereby the invisible comes to appearance, a confrontation at odds with the public nature of events like Documenta itself.[2]

In his remarks, Heidegger wastes no time assessing the role of sculpture today, as compared to that of ancient Greece: "The art of the sculptor, for example, required no galleries and exhibitions, even the art of the Romans needed no Documenta" (*KPR* 6).[3] While sculpture might seem to have found a new place today, with public sculpture increasingly prevalent in the design of public and corporate spaces, Heidegger views this as complicit with the planned order of industrial society: "Now one is quick to point out that today plastic art, and here above all sculpture, proceeds once again to find its proper place. For it enters into a new relationship with the industrial landscape, filing itself alongside architecture and public works. Sculpture becomes co-determinative for spatial planning" (*KPR* 6). Such public art (*öffentliche Kunst*) comes to be the least open (*offen*) of all. It feeds a culture-hungry public with lived experiences that accumulate in an interior.[4] Heidegger also takes issue with art critics whose extensive writings only paper over the fact that our art no longer speaks but stands in need of commentary (unlike the Greeks, we have a "literature *about* art"; *KPR* 7). Documenta is

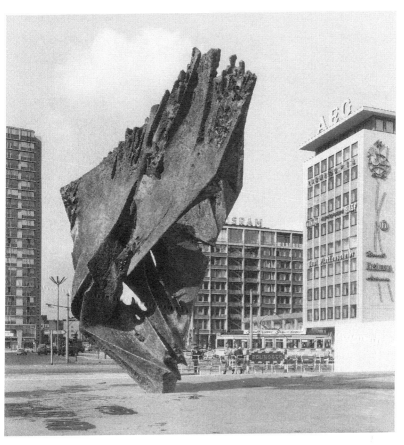

FIGURE 2.1 Bernhard Heiliger, *Die Flamme* (The Flame), 1962. Bronze, 700 cm. Photo courtesy of the Bernhard Heiliger Stiftung. © 2009 Artists Rights Society (ARS), New York / VG Bild-Kunst, Bonn.

again singled out in this regard, for without naming names Heidegger cites the motto of Documenta III by curator Werner Haftmann ("a respected art expert and art writer") as typical of contemporary thinking about art: "Art is what important artists make" (*KPR* 8). Here Heidegger points out the circular character of such a saying, art is what artists make and artists are the ones who make art. The explanatory approach of this manner of art criticism (and not only of art criticism) flees the matter at issue in order to explain it away by recourse to something else. Documenta, then, is exemplary of art in the public sphere as a key nexus of the culture industry. Artists like Heiliger and events like Documenta cater to lived experience and further the program of industrial society. As Heidegger writes to his wife Elfride on the day after his speech, "I do not fit in with this modern art industry" (*MLS* 354 / 291; tm).

Nevertheless, Heidegger agrees that the sculptor is capable of effecting a confrontation with this space: "Who is a sculptor? Answer: an artist who confronts [auseinandersetzt] space in his own way" (*KPR* 8). "*He enacts* [*vollzieht*] a confrontation with space" (*KPR* 7). The nature of this confrontation is lost on critic and artist alike: "Can the sculptor as sculptor, that is, by means of a sculpture, say what space is and what a confrontation with space means? He cannot" (*KPR* 7). This is no failing on the part of the artist, Heidegger insists, but a result of the fact that "art as such is not a possible theme for artistic shaping" (*KPR* 7).

Yet Heidegger himself is not quite at ease with this exclusion of the artist from thinking of art, as a note appended to the text at this point reveals: "but poetry—of the poets" (*KPR* 18, n. 3). The poet would be able to poetize poetry (one thinks of Hölderlin's poetizing of the poetic vocation, *Dichterberuf*), why

not the artist art? The sculptor's confrontation (*Auseinandersetzung*) is capable of interrupting the smooth functioning of the plan, of setting (*setzen*) apart (*auseinander*) a place that will disturb the seamless field over which proceeds the unending circulation of ersatz commodities. The sculptor brings about this confrontation by setting forth in the work something that is neither present nor absent. In so doing, the sculptor's act is one of *poiēsis* (ποίησις), the ancient Greek sense of production; "ποίησις means: bringing-here-forth, forth into unconcealment and here from out of concealment, this however so that the concealed and the concealing are not pushed aside, but instead are precisely preserved" (KPR 15–16). The confrontation with space is not a matter of presenting what is unconcealed against the background of concealment, but of presenting concealment itself within unconcealment. Concealment must announce itself and does so in the work, undoing the opposition of presence and absence.

By revealing concealment within unconcealment, sculpture unfurls a space of varied densities. Space is thickened (*verdichtet*), something already a challenge to the circulation of the ersatz, which relies on a frictionless empty field for the most efficient cycle of consumption. The setting apart of the sculptural confrontation stretches and tightens space, rendering it heterogeneous. That the artwork is capable of thickening space leads Heidegger to claim, "All art is in its own way poetry [Dichtung]" (KPR 16). Consequently, sculpture *is* capable of thematizing art's role, for art is nothing but a confrontation that opens a place beyond itself. In this way, as exposed and relational, all sculpture is "public" sculpture.

This Body My Abode

For an experience of the sculptural confrontation with space, the human body cannot be an inert mass (*Körper*), it must be a lively responsive body (*Leib*), sensitive to the qualifications of space that sculpture renders sensible. Rather than imagine this lived body as something we animate from within as a vehicle of expression, the body is an opening to relation: "The human has no body and is no body, but rather it lives its body [Leib]. The human lives in that it bodies [leibt], and thus is it admitted into the open of space, and through this self-admittance it holds itself already from the outset in a relation to its fellow humans and things" (*KPR* 13). The body brings us to a world not as something separate from us, not as a tool we might use (our arrival is a "self-admittance"), but as who we are. The body functions not so much as a passport but as a passage; there is nothing identifiable or localizable about it in any one place: "The human is not limited by the superfice of his supposed body" (*KPR* 13), rather we always extend beyond the skin, with the body a perpetual entrance to the world. We are always arriving:

> When I stand here, then I only stand here as a human insofar as I am simultaneously there by the window and, for example, outside on the street and in town, briefly put: I am in a world. If I go to the door, then I do not transport my body to the door, rather I alter my residency ("bodying" ["Leiben"]), the always already extant proximity and distance of the things; the breadth and narrowness wherein they appear changes. (*KPR* 13–14)[5]

The body in its bodying transitions through space with ebbs and flows of distance and nearness. My residency in the world, my *Aufenthalt*, is simul-

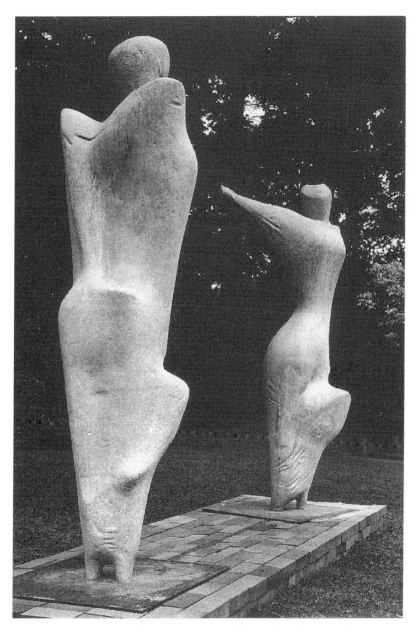

FIGURE 2.2 Bernhard Heiliger, *Zwei Figuren in Beziehung II* (Two Figures in Relation II), 1954. Asbestos cement, 250 cm. Photo courtesy of the Bernhard Heiliger Stiftung. © 2009 Artists Rights Society (ARS), New York / VG Bild-Kunst, Bonn.

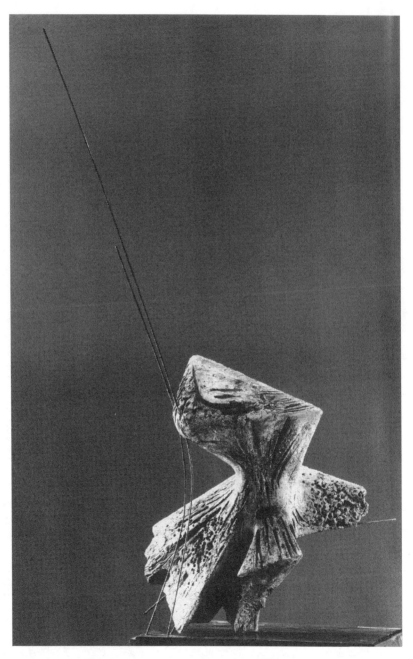

FIGURE 2.3 Bernhard Heiliger, *Phönix II* (Phoenix II), 1961. Bronze, 75 cm. Photo courtesy of the Ewald Gnilka Fotonegativ-Archiv (Universität der Künste Berlin, Universitätsarchiv).

taneously a matter of supporting myself up, into, and through the world, sharing a world beyond myself. Heidegger does not argue that the body is a means for this, not a means by which I could go to the door right now. Nor does he argue that thanks to the body I *can* go to the door or *can* go into town. The body is not thought as an "I can" that would realize a finite set of possibilities (that I *could* go up to the window, that I *could* go into town). Rather *I am already in town*. It would be a mistake to think that the body is here and only *possibly* elsewhere and then to derive these possibilities from the powers and abilities of that body. The body is no "I can," but an "I am."[6] The body is the extent of my reach, is where I touch, it is the site for all that concerns me and for all that approaches me. I can be touched from a distance only because my body is already at that distance from me. My body is my abode and my abode is the world.

But I could not be in space in such a manner if space itself remained unaffected and did not receive me and distribute me past myself. The history of philosophy has subordinated space to bodies: "Despite all the differences in the manner of thinking between Greek and modern thinking, space is construed in the same way, as from bodies" (*KPR* 11). Space has been construed on the basis of bodies (encapsulated objects) as either occupied or empty. Sculpture provides the impetus for thinking space and body together. Against the negative construal of such a space (space as no body), Heidegger unfolds a positive conception: "What therefore is space as space? Answer: space spaces [der Raum räumt]. Spacing means clearing out [roden], making free, setting free into a free area, an open. Insofar as space spaces, freely gives a free area, then it first affords [gewährt] with this free area the possibility of regions, of near and far, of directions and bounds, the possibilities of distances and

magnitudes" (*KPR* 13). What space *is* is nothing settled and fixed in place. Rather, as space, space is a movement, a "spacing." There is no space that would be unaffected or neutral with regard to the bodies around it (the bodies surrounding space). The spacing of space is partly the permissiveness of bringing these bodies out of themselves and granting them passage beyond themselves. Space is a separation that allows for contact, not a bridgeable gap between us and the world, for we are already underway in space and in the world. As this permissive, differentiating, and mediating fluctuation, the spacing of space itself gives rise to a contoured, variegated field of space: space no longer abstract and frictionless, but itself already gathering and furrowing and stretching out and snapping back, into regions, distances, directions, and bounds.

Whereas Heiliger's earlier sculptures presented forms that appeared trapped and desperate to escape, the works of the Erker exhibition indicate a more refined conception of exteriority, where the forms show signs of distress and weathering. Rather than attending to figures struggling to get out of themselves, Heiliger turns to figures suffering this outside already. The purity of the surface is compromised, matter is striated and punctured, eroded. His works enter time, our fleshy realm of bodily decay.

Head First into the World

Nearly forty years after *Being and Time*, Heidegger observes that there is still an inadequate sense of what it means to be in a world: "Existentialism, the atheistic brand of Sartre as well as the Christian, completely misinterprets the phenomenon of being-in-the-world. One supposes that this title means: the human would be in the world as the chair is in the room and water in the glass" (*KPR* 14). Just as the human does not "have" a body, so too does the world not have the human. But neither does being-in-the-world mean that the human would be suspended in a meaningless void. Being-in-the-world is not my place *in* the world, but my place *as* the world. I am a being who is quite literally "in" the world, to be encountered there—*that world is my body*, my body as *lived in-the-world*. I live *bodily*, which is to say *worldly*, and my body radiates beyond itself.

To be in the world is to be thoroughly penetrated by world, for it to run through oneself and out of oneself, permeating and buoyant. It is not only that world runs through us, but we are taken up and drawn out with it, both surged through and pulled along. One is not in the world without being it and one cannot be oneself without this continual bodily entry to world. This interplay of body and space is what Heidegger admires in the series of heads that Heiliger sculpted.

Heidegger had previously mentioned the head (*Haupt*) in a much different context in 1945, while reflecting upon his 1933 rectoral address, "The Self-Assertion [Selbstbehauptung] of the German University." Heidegger claims that the references to "struggle [Kampf]" in the text have to be understood in terms of the Heraclitean *polemos* (πόλεμος), which he identifies as "confrontation [Auseinandersetzung]." The self-assertion of the university is a willingness to confront the unknown and bring about a "confrontational reflection

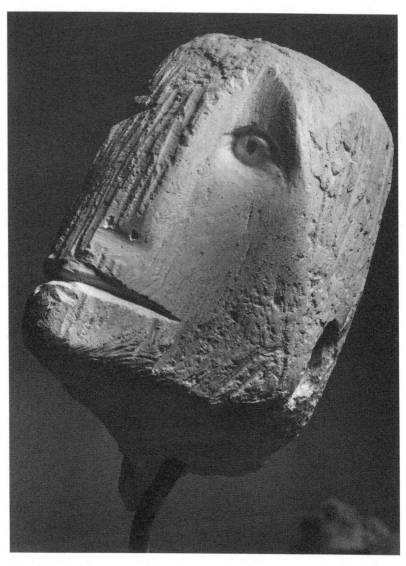

FIGURE 2.4 Bernhard Heiliger, *Gesicht* (Face), 1956. Cement mold, 39 cm. Photo courtesy of the Ewald Gnilka Fotonegativ-Archiv (Universität der Künste Berlin, Universitätsarchiv). © 2009 Artists Rights Society (ARS), New York / VG Bild-Kunst, Bonn.

on the essential realm of science."[7] The head here is a pointing out to the unknown in a willing confrontation. In the same text, Heidegger balks at those who would understand his address as advocating the National Socialist doctrine that "the true is what is useful to the people."[8] Precisely such a conception of "truth" misses the exposure to alterity that the *Behauptung* calls for. Were he to have proposed such a thing, Heidegger fumes, the address would have been better titled, "The Self-Decapitation [Selbstenthauptung] of the German University."[9] The head is always exposed.

One of the more "abstract" of Heiliger's sculpted heads (*Gesicht*, 1956) was displayed at the Erker-Galerie exhibition. In his opening remarks, Heidegger addressed the relation of the head to world: "A head is no body equipped with eyes and ears, but instead a bodily phenomenon, stamped by the looking and hearing of a being-in-the-world. When the artist models a head, he only seems to copy the visible surfaces; in truth he shapes the properly invisible, namely the way in which this head looks in the world, how it holds itself up in the open of space, approached by the humans and things therein" (*KPR* 14). The sculptor sculpts the invisible. In sculpting the head, Heiliger sculpts the world that models this face, the invisible world that cannot be seen but which appears nonetheless. The world is already here in our face, and the face diffuses throughout the world in turn. The sculptor sculpts the announcement and approach of that invisible world in the face. But this is not to say that the artist would collect only the marks and traces of a world gone by: that head is already world enough.[10] In sculpting the head, Heiliger sculpts both the vertiginous abyss that marks the head as well as its own shaping effect upon that abyss. What the sculptor enacts in the formative gesture are the marks of the beyond as it reaches into this face and as the face reaches into it.[11] The sculptor

makes evident that the work belongs to the world, that it is marked by what lies outside it. "The artist brings the essentially invisible into figure and, when he corresponds to the essence of art, each time allows something to be caught sight of which hitherto had never been seen" (*KPR* 14). What had never been seen is the incomprehensible beyond of the face that wells forth and is met by the infinite vagaries of the world. This "beyond" sees and shapes us until its sighting determines how we ourselves come to see. The artist shows this reciprocal relation of sightings. The sculptor sees that to see is to be seen, that to be is to be perceived, and makes the work the medium of this relationality.[12]

The day after the gallery opening, Heiliger sculpted the head of Heidegger,[13] one of the last heads he sculpted as this phase of his work drew to a close and he turned his attention to more outdoor and public works. Or rather, he turned his attention to form as such, the face being already outdoors and public, as Heiliger himself had shown.

Sculpture, Like Birds, Between Earth and Sky

After visiting Heiliger's workshop, Heidegger wrote the sculptor a brief letter of thanks:

Dear Bernhard Heiliger,

The hours in your workshop—I am pleased to say—have opened my eyes to what your current work is able to say to the people of today and those to come. To say means to show.

And you show the emergence of the earth into the earthly sky still veiled from us. Your works no longer present—they place us in a residence between the earth and sky—the *movement itself* of such a growing into the liberating free space, and precisely *this*, is made manifest—a "transfiguration" (not an idealization) of being—from out of a concealed source.

The poet dwells in your workshop—

A friendly greeting.

Yours,

Martin Heidegger[14]

Heiliger's sculpture grants us a residency within the interstitial space of the between. The earthen materiality of these forms, somewhere between stone, bone, and wood, emerges into the light of the sky. The world between the earth and the sky is nothing tranquil in itself, but a world of movement. Heiliger says as much in a short reflection entitled "Thoughts," included in the exhibition catalog: "Not stagnation, but movement—to be awake *between the things*, that are yet grasped in 'becoming' and are scarcely lit up from out of the darkness, to look into the things and into the turmoil and to create

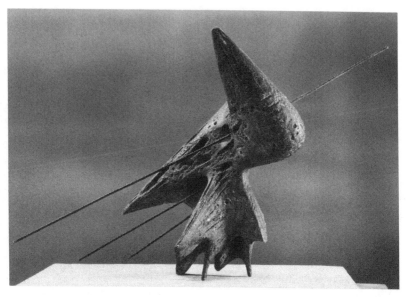

FIGURE 2.5 Bernhard Heiliger, *Vogeltod* (Bird Death), 1961. Bronze, 38.5 cm.
Photo courtesy of the Ewald Gnilka Fotonegativ-Archiv (Universität der Künste Berlin,
Universitätsarchiv). © 2009 Artists Rights Society (ARS), New York / VG Bild-Kunst, Bonn.

from out of that" (*BH* 21; em). Becoming is a movement out of darkness into light, a movement within twilight, we might say. The becoming of things is turmoil, as Heiliger's sculptures surge up out of the dark to display "the broken open wounds of a form that is grasped while still in 'emergence'—a sculpture in 'becoming'" (*BH* 21).

These broken-open forms cannot contain themselves. The exuberance of emergence incompletes them. Or rather, the exuberance of emergence is a becoming in place. The broken form as open is transitional, not a completed whole and yet here nonetheless. But this does not mean that there is more to arrive, there is nothing missing or lacking to these figures. The sculpture is a whole while uncompleted. Its wholeness lies in an openness to what surrounds and surpasses it. So opened, the sculpture falls into the world, it emerges into world. This emergence takes place (or gives itself as a place) alongside and against all that is, with all that is providing the maieuetic supporting context for its arrival. The sculpture is inseparable from these surroundings; this is what openness means. To be open is not to be open at a point and closed off at another, it is to be open through and through, so much so that everything about oneself is destabilized, translated, emergent. Otherwise put, openness means existence in the midst of things, in the middle of things. Heiliger writes that "this *middle-realm* [Zwischenreich] is most fascinating to me; my strength is to lend it visibility, expression, and tangibility" (*BH* 21; em).

The secret that dwells in Heiliger's workshop is the secret that he brings to his work, nothing that he himself would know in advance: "The strongest findings of form are those that become graspable by pure accident through what is at first entirely unknown to me" (*BH* 21). What is unknown, what is unknowable, is relationality itself. Unable to be contained within a knowing

subject, since itself nothing contained, but instead the connectivity of things and the spacing of them that provides them their contact and gives them support, this relationality can never be known and remains the secret of the thing. A secret, it should be noted, that itself is not possessed by the thing but is a secret that exists outside of the thing—the secret as the thing's belonging, *the secret as the world.*

With this, Heiliger's sculpture come into accord with the sculptural works of the Greeks. Heiliger's works show and say, Heidegger says, and Greek works, too, "*spoke for themselves.* They spoke, that is, they showed wherein the human belonged, they allowed one to perceive whence the human would receive his determination" (*KPR* 5). To exist in the between is to be not wholly within oneself but exposed at one's limits, and through this to be touched by what abandons its own enclosure to reach out to you. To be among things names a middle ground no longer derived from bodies or distinct from them, but a middle of traversal and passage, an admission of the beyond into oneself, a being-between. Birds travel with us as we make our way through the between. When everything is understood as open, everything pours out beyond itself. There is no longer any outside and nowhere to escape to when we are already outside of ourselves. Just as birds rise and soar only to return to ground, Heiliger's sculptures likewise take place within this between, they often bear avian titles for just this reason: *Vogeltod* (Bird Death), *Vogelbaum* (Bird Tree), *Mondvogel* (Moon Bird), *Vogelschrei* (Bird Cry), *Phönix II* (Phoenix II), a relief entitled *Veränderlicher Flug* (Alterable Flight), to name only those on display when Heidegger spoke. Strange birds, to say the least.

Articulation 2: Decay and Erosion

Heiliger's earthen forms that enter the between enter a world of turmoil and friction. This very appearing is distressing and the material bears witness to this; what seems stone is striated, wood, grained, bone, desiccated. Heiliger's sculptures show the movement of emergence, but equally so, they attest to the fact that movement is a wearing away. To be in the between is to be in becoming, to be sure, but becoming is never simply a becoming toward something, but a becoming away from something as well. To become is to erode. Heiliger's sculptures show the movement of decay and erosion; the decay of flight, the decay of every orbit, and the erosion of all that appears.

These figures are not "idealizations"; Heidegger is correct in this: they are far too weathered. As entrances to the between, these sculptures enter a world that is no undifferentiated empty space but a world of people, places, bodies, weather, variation and variegation, striation and differentiation, swells and recessions. To appear here is to have to find a place amid the turmoil, the currents, and the undertow of bodily existence. And even when a place is found, it is always out in the open, exposed to the elements, or rather *the* element, for there is only "one," space. Space is filled with excoriation, we dissolve into it, fray off and dwindle into it, and all this silt shifts in waves through the air, along the ground, swirls, flows, and abrases all appearances alike. Every relation is excoriatingly abrasive (and this not simply in a "material" sense), while to appear is always to appear in relation. We change with every relation and every distance, however spiritual or illusory it may be. Appearance is the "material" that wears at us. The shine of it dulls us after a while.

Becoming as movement into the world decomposes any sense of an ideal identity, simultaneously shedding one's closure and opening one to the

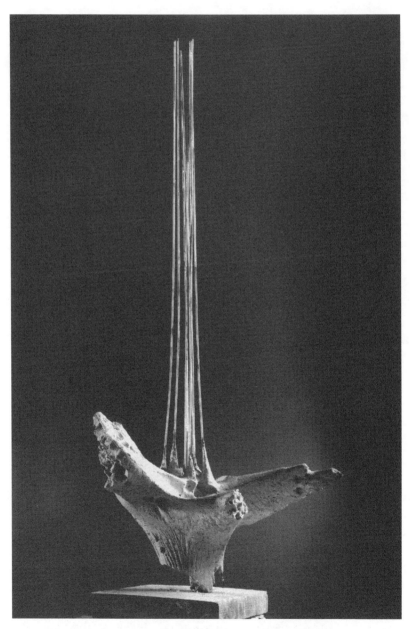

FIGURE 2.6 Bernhard Heiliger, *Vogelschrei* (Bird Cry), 1964. Bronze, 130 cm.
Photo courtesy of the Ewald Gnilka Fotonegativ-Archiv (Universität der Künste Berlin,
Universitätsarchiv). © 2009 Artists Rights Society (ARS), New York / VG Bild-Kunst, Bonn.

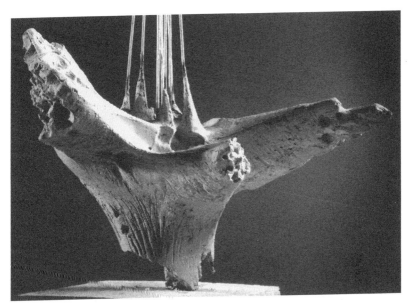

FIGURE 2.7 Bernhard Heiliger, Detail of *Vogelschrei* (Bird Cry). Photo courtesy of the Ewald Gnilka Fotonegativ-Archiv (Universität der Künste Berlin, Universitätsarchiv). © 2009 Artists Rights Society (ARS), New York / VG Bild-Kunst, Bonn.

infective detritus of the world. To give oneself is always to give *oneself*, even where it would seem no body is involved. All that *is* is marked and noted, differentiated (spaced) by its relation to another. One's appearance affects the world, leaves its mark, but the same marked world returns the favor, as world always leaves its mark on you. Nothing is unscathed. Every sighting marks the seen, just as everything seen marks the seer. We are weathered by the world, eroded in the between. Our agreement is to erode together.

This is erosion as transfiguration (*Verklärung*), to use Heidegger's term, a movement to clarity. But clarity here is found in the interpenetration of body and space, where body is riddled through by space and space buoys up the eroded body. Transfiguration changes the density of existence. We see what you have been through (and what has been through you). You become clear.

Sculpture appears in the world and bears the marks of that appearance. But it also places its mark on the world, lays its claim on it. Sculpture changes the space around it. Its entrances and invitations change the density and thickness of things. Sculpture changes the texture of the space around it as each work eddies forth turbulences into the smoothness of the world. Sculptures push at the space that runs through us. Sculptures touch us for this reason, they pull us out of ourselves as well. The sculpture in place disrupts the homogeneity of space and the encapsulation of the subject. It tugs both of these at once and testifies to our belonging to world. Heiliger's sculptures attest to the fact that we do not belong to this world for long. It wears us down and erodes us. We die of our relations. Our death is nothing we possess, but it is not for that reason nowhere to be found. It is right there in front of us, but behind us, too, and all around. We meet it every day and in every relation of this world.

Heiliger's sculpture shapes itself into the joints of the world showing the connectivity that keeps us aloft and afloat. The world fits into these strange sockets and cups, these almost pelvic joints. Heiliger's "birds" are so many articulations of the world, their abode is our abode, the swoop of their lines a yearning for world. They show existence itself, appearance as such, to be an articulation *of* the between. Articulation here like bones coming together in a clasping and nestling of one in the other, where the two together effect a pivot that neither could capably achieve on its own, where the two support each other without fusing to one. These joints are the truth of existence, our being with the world and belonging so fully to something beyond us, something that at times restricts us and hinders us, but belonging to it so fully that it kills us. We die in the world, of the world; we decay. Decay is perpetual entry to a world of erosion, a participation in the jointure of the between. Erosion is articulation (showing is a saying).

Excursus on the Goddess Athena

Shaping the Invisible World

In a 1967 lecture in Athens, "The Origin of Art and the Definition of Thinking," Heidegger considers the origin of the artwork for the ancient Greeks and its place for us today in an age of cybernetics and "futurology." In the course of an opening reflection upon the goddess Athena as she appears in two bas-reliefs, Heidegger presents an interpretation of *technē* that widely differs from the medieval sense of finished creation in presenting *technē* as the bringing forth of a world of relations.

In the Atlas Metope, Athena appears alongside Atlas, helping him carry the world. Homer named Athena the *polymētis* (πολύμητις), of many counsels, and Heidegger notes that her advising, like her aid to Atlas, assists in the accomplishment of something. Athena is the goddess of such achievement, "Athena reigns everywhere that humans bring something forth, into the light, bring something along its way, bring something into a work, act and do" (*HK* 12). She is the goddess of the producers: "Athena dispenses her particular advice to the men who produce the equipment, vessels, and decorations" (*HK* 12). She is the goddess, in other words, of the *technitēs* (τεχνίτης), of those who produce in accordance with a knowledge of things, according to a *technē*, where *technē* "names a type of knowing. It does not mean a making and a finishing" (*HK* 12). In fact, the *technitēs* is "neither a technician nor a manual laborer," but an artist (*HK* 13). The human artist creates in a manner distinct from that of the sculptor God, whose work is complete and finished. But if the *technitēs* is not invested in the production of finished works, what exactly is he or she doing?

For Heidegger, the artist brings forth not so much a product as that which is located in no particular product, something "invisible." We know from the Heiliger engagement that this invisible is the world, exceeding every particular

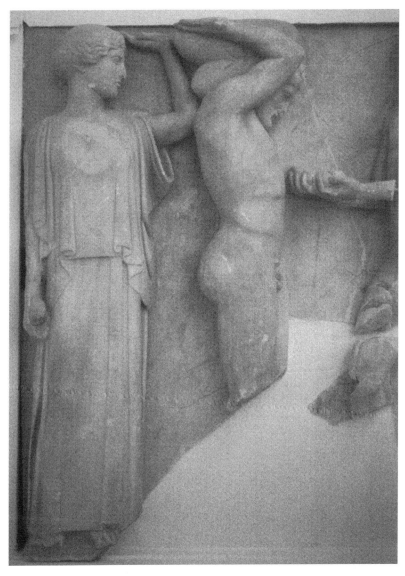

FIGURE 3.1 *Herakles Receiving the Apples of the Esperides from Atlas*. Metope from the Temple of Zeus in Olympia, 468–456 B.C.E. Marble, 160 cm. Photo: Vanni / Art Resource, NY.

thing but nonetheless essential to each. The knowing of the artist is a sighting of the invisible: "Because art as *technē* resides in a knowing, because such knowing resides in that which indicates the form, gives the measure, but remains yet invisible, and which first must be brought into the visibility and perceptibility of the work, for this reason such a glance forward into what has not yet been sighted requires vision and light in an exceptional way" (*HK* 13). To see the invisible (and to see it *as* invisible) requires an unusual light, which is to say that our relation to the invisible is only possible through a medium of appearance. For it is the surrounding world that shapes the figure, that gives it its form, a world in which it too participates in the shaping. But it also requires an unusual form of sight, one that is able to see in this light. Sight and light belong together, another insight into a thinking of mediation. The artist sees through the light to catch sight of what is as yet invisible and thus receives a guide for bringing the work to light.

But we must forego the thought of a body that could otherwise exist outside its medium (its "element," to use a favored term of Heidegger's). The sight we are discussing does not take place within an external light, it is that light itself. Athena's eyes provide their own light, though this is all too clumsy a way of saying that her eyes participate in the shining of the world. Athena is named *glaukōpis* (γλαυκῶπις) for her "gleaming-illuminating" eyes; they are *glaukos* (γλαυκός), a word that names "the radiant gleam of the ocean, of the stars, the moon, but also the shimmer of the olive trees" (*HK* 13). Eyes are not in or out of the light, they radiantly (relationally) gleam through a world always already illuminated. It is a gleam shared by the owl, *hē glaux* (ἡ γλαύξ), her familiar, the animal with "fiery-glowing" eyes, who sees "through the night and makes visible what is otherwise invisible" (*HK* 13).

This earthly vision is able to catch sight of the otherwise invisible. But it is Athena herself who is invisible in the metope, as Heidegger notes at the outset of his lecture: "The Atlas Metope of the Temple of Zeus at Olympia lets the goddess appear: invisible yet while standing by and at the same time distant with the high distance of the divinity" (*HK* 12). What is depicted is a scene from the tenth labor of Herakles, his quest for the apples of the Hesperides. Herakles takes the weight of the world off the shoulders of Atlas so that Atlas might retrieve the golden apples. But Herakles cannot hold up the world alone, he can only do so with the help of the invisible Athena.

What is invisible is the support of the world, everything beyond the sculpture that the *technitēs* would produce. To see the invisible is to see the relations of things, not as a medium across from oneself but a medium in which one already is, whereby to see it is to illuminate it with your very eyes. We participate with ocean, stars, moon, olive trees, and owls in carrying this out. To catch sight of the invisible is to sight the relations that buoy us up so that we might bob atop the surface of the world, like figures in a relief.[1]

The Limit of Relief

In the Acropolis relief of a "mourning" Athena, we encounter Athena the *skeptomenē* (σκεπτομένη), the meditative one (*die Sinnende*).[2] Heidegger calls on this relief to show us what the knowledge of *technē* catches sight of in advance. As Heidegger notes, Athena's gaze is fixed upon "the boundary stone [Grenzstein], upon the limit [die Grenze]" (*HK* 13). Again, Heidegger is at pains to declare the "productive" force of limit: "The limit, however, is not only the outline and frame, not only that whereby something ceases. Limit means that whereby something is gathered into its ownness, in order to appear from out of this in its fullness, to come forth into presence" (*HK* 13). Such a coming forth into presence is a perpetual *entering* of the world, for the nature of limit is such that it keeps delivering the thing out beyond itself. Paradoxically enough, the limit *gives the thing to the world endlessly*. In giving form to the thing, in other words, the artist co-creates the invisible world beyond the thing into which it radiates. By her gaze, Athena tells us that the artist must keep in view the limit, must negotiate with limitation, if the invisible is to show itself in the work.

But Athena looks not only at the edges of the boundary stone, she looks at the stone itself as natural being: "The meditative gaze of the goddess looks not only upon the invisible form of possible works of humans. Indeed, before all this, Athena's gaze rests on that which lets the things that do not first require human production emerge by themselves into the stamping [Gepräge] of their presence. Long ago, the Greeks named this φύσις [*physis*]" (*HK* 13–14). Natural beings, *ta physika* (τὰ φύσικα), are likewise delimited beings; they emerge into the limits proper to them. They emerge into the world as well and are "stamped" by the continuous event of it. Humans do not bring forth

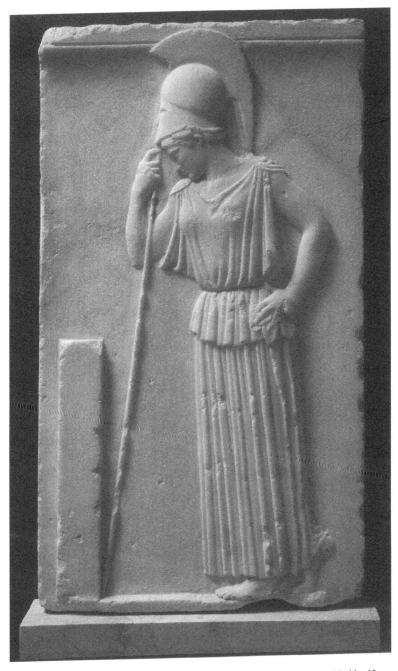

FIGURE 3.2 *Pensive Athena*. Votive relief from the Acropolis, 470–450 B.C.E. Marble, 48 cm.
Photo: Nimatallah / Art Resource, New York.

ta physika, but what they do bring forth via *technē* is not without relation to *physis*. The works that humans produce are nothing alienated from nature or artificial in the depreciative sense, but could even be said to be needed by nature:

> Only here in Hellas, where the entirety of the world as φύσις [*physis*] has promised itself to the human and taken him under its charge, can and must human perception and action correspond to this claim, as soon as the human himself is urged by this claim to bring forth into presence, by his own capacity, that which, as work, will allow a world to appear which has not hitherto appeared. (*HK* 14)

Human *technē* responds to the claims of *physis*, that there be a rebirth of world, that all appearance participate in that worlding, the human included and precisely as *technitēs*. The *technitēs* brings forth the world in bringing forth the work, because for the work to be a work it must be delimited. The artist changes the world. What the *technitēs* knows is that bringing the limit to the work is equally a bringing of the work to the world and the world to the work. The expertise of the artist is a knowledge of limits, that no limit is one-sided, that all delimitation likewise exposes, that what limits constrain they likewise deliver. The work and *physis* are both entrances into this free space. To hearken to the claim of *physis* is to keep in sight the extent to which what is newly created as a work of art will always be a "stamping" of the physical. The call from *physis* for human works is thus an invitation to impress the world but also to let that world impress upon you. *Technē* is thus a way of attending to the place of *physis* in the world. The claim of *physis* asks and of-

fers a relationship that neither partner would possess in advance—it offers a new world. In this respect, Heidegger can claim that "φύσις [*physis*] and τέχνη [*technē*] belong in a secret way together" (*HK* 14).[3]

The bas-relief is a perfect example of how a proper conception of limit makes art a tending to the natural and the sculpting of relief a tending to the stone (and each of the sculptors with whom Heidegger concerns himself— Barlach, Heiliger, and Chillida—works in relief). In relief, the figure rises from the ground, delimited, to be sure, but at the same time also extending itself into the space between figures, into and along the recessive matrix of the stone. The figure that bobs up above the surface of the stone is not removed from its medium in any way, but is, instead, a particular convolution and up-swelling of that medium itself. Matter rises into form from out of this matrix, bulging from the ground, thickened (*verdichtet*) in its belonging to ground, or we might say "poetized"—a poetizing which Heidegger identified as the es-sence of art. Relief shows that limits never really isolate, that the figure is not trapped in itself to antagonistically confront and assail an opposing ground. Figure belongs to ground and varies it, ripples it, teases it into swells and waves. The art of the sculptor is just such a pleasuring, tending, teasing of stone.

Eduardo Chillida

THE ART OF DWELLING

A Nonconfrontational Art

Heidegger was introduced to the work of Eduardo Chillida by his friend Heinrich Wiegand Petzet, who had met the sculptor in 1962. Heidegger and Chillida would not personally meet until 1968 at the Erker-Galerie celebration for the publication of Heidegger's essay "Art and Space" in a limited edition booklet including seven lithocollages by Chillida.[1] In one of Petzet's conversations with Heidegger about Chillida, during which they viewed and discussed photographs of the sculptor's works, Petzet relayed to Heidegger Chillida's observation that "it is not the form with which I am concerned, but the relation of forms to one another—the relation that arises among them" (*ASZ* 165 / 156). Petzet reports that the ensuing discussion with Heidegger "touched upon the fundamental problem of this sculptor, namely, the incorporation [Einbeziehung] of 'space' in his work" (*ASZ* 165 / 156–57). In the essay "Art and Space," Heidegger takes on the "fundamental problem" of this sculptor, that of space and the artwork. In considering the work of Bernhard Heiliger four years earlier, this relation was cast as a confrontation (*Auseinandersetzung*) between art and space. Now, however, considering Chillida, the emphasis no longer falls upon the setting-apart of a confrontation, but instead on a mutual participation of space and work in a provisionally nameless medium of appearance. The space of sculpture will come to be seen as the spacing of sense and relation.

The opening pages of Heidegger's essay present the production of the sculptural work as typically understood to be an act of delimitation: "The forming of it happens by delimitation [Abgrenzung] as setting up an enclosing and excluding limit [als Ein- und Aus-grenzen]" (*GA* 13: 204 / *AS* 3; tm). The enclosing and excluding nature of this delimitation establishes an impermeable barrier separating the present body from the empty space surrounding the work

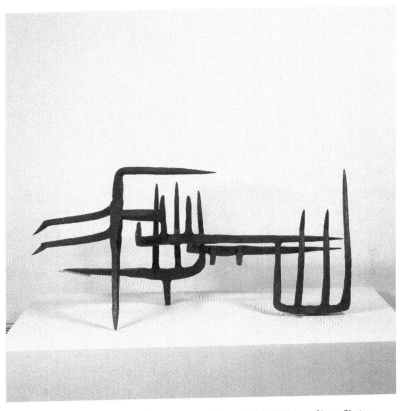

FIGURE 4.1 Eduardo Chillida, *Música callada* (Silent Music), 1955. Iron, 63 cm. Photo: Image Bank VEGAP. © 2009 Artists Rights Society (ARS), New York / VEGAP, Madrid.

(from which the work is absent). But the opposition here is anything but stable. As Heidegger had previously discussed in relation to Barlach, empty space functions as a provocation to the ever-increasing will, as a precondition for its growth. Empty space challenges the will to an "occupying seizure [Besitzergreifung]" or "technological-scientific conquest [Eroberung]" of space (*GA* 13: 204 / *AS* 3; tm). Art as confrontation (*Auseinandersetzung*) participates in this assault: "Space—is it that which, in the meantime [since Newton], challenges modern man increasingly and ever more obstinately to its utter domination? Does not modern plastic art also abide by this challenge insofar as it understands itself as a confrontation [Auseinandersetzung] with space? Does it not thereby find itself confirmed in its modern character?" (*GA* 13: 204 / *AS* 4; tm). Confrontation perhaps still speaks too much of the idea of contest and will, of the revelation of truth through agonistic competition—opposition, conquest, and seizure: "Art as sculpture: no occupying seizure of space. Sculpture would be no confrontation with space" (*GA* 13: 208 / *AS* 7; tm).

For this to be the case, though, space can no longer be construed as void (empty). Presence and absence can only confront each other as oppositions, as they are so defined. The separation of the confrontation (*Auseinandersetzung*) cannot divide across a void. Instead, sculpture must be a continuous entry into space, must extend itself through space (without this becoming a matter of exclusive possession). The limit of the thing is where it begins, where space begins its way into the sculpture and the sculpture begins its way into space. Sculpture becomes a work of relation, moving beyond itself and into space without conquering that space or making it a captured and surrounded possession.[2] Sculpture becomes indissociable from space. Through such reverberations, space is no longer empty but also not yet occupied.

In an interview conducted in 1967, a year before the Erker-Galerie meeting, Chillida describes his work in terms that remained with him his whole career, as a matter of music or rhythm (if only a silent music). And while here he imagines space as a void, he nevertheless regards it as permeated by tensions and vibrations, that is to say, as no void at all:

> Sculpture and music exist in the same harmonious and ever developing space. The volume of musical sound fills the silence with tension; similarly there could be no volume in sculpture without the emptiness of space. In the void the form can continue to vibrate beyond its own limits; the space and the volume together, selecting from all the potential structures inherent in the form, build up its final shape. The rhythm is determined by the form and is renewed with it.[3]

Both Heidegger and Chillida seek a space that would no longer be void but would be traversed by tension and the vibrations of form, a space permeated by the things that take place throughout it, a poetic space of relation accomplished through the incorporation of space into the sculpture and the incorporation of the sculpture into space.[4] In his lengthy interview with Martín de Ugalde, Chillida proposes that the relationship between body and spirit be understood in terms of their velocity: "I have the impression that it is speed that distinguishes matter from spirit . . . spirit, an incredibly fast matter . . . and matter, a slow spirit."[5] Spirit-matter, no longer antipodal.

And the same could be said of matter and space (and velocity is just another way that bodies are of space): there is no antipodal opposition between them. For this reason, sculpture can no longer be viewed as a confrontation with space. A confrontation requires two parties.

Truth in Context

To think this space, Heidegger follows an etymological clue to consider space (*Raum*) as an event of spacing (*Räumen*), which takes place as a clearing away or making room (*Einräumen*). *Ein-räumen* is literally an insertion (*Ein-*) of space that achieves a spacing apart (*räumen*).[6] In this spacing apart, however, a relation is supported between the separated parties. Spacing is a way of thinking this connectivity of things in the world. The separation of things is never so complete as to completely disengage things from each other. Nothing can be detached from space, or rather, nothing can be so detached that we do not suffer its detachment (and consequently maintain the connection). The spacing of space is the elasticity of these relations, and ultimately a name for the aporia of belonging.

Heidegger identifies two guiding aspects of spacing as making room: "How does spacing occur? Is it not a making room, and this, again, in the twofold manner of an admitting and an arranging?" (*GA* 13: 207 /*AS* 6; tm). On the one hand, space allows things to appear, permits them entry: "It lets the open reign, which, among other things, allows for the appearance of presencing things" (*GA* 13: 207 /*AS* 6; tm). The second moment of making room, inseparable from this first, is that "making room prepares for things the possibility to belong to their respective whither [ihr jeweiliges Wohin] and, from this, to each other" (*GA* 13: 207 /*AS* 6; tm). Appearance in space is each time an appearance out through space. What appears is from the outset drawn out beyond itself; what appears is this *Wohin*, this "whither" of relation that is new each time. Space is utterly relational, a distribution in all directions.

The admission into space is a giving of the thing to relation.[7] Heidegger speaks of spacing also in terms of a giving: "Spacing is a free-giving of places

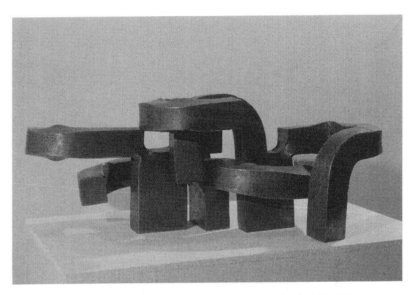

FIGURE 4.2 Eduardo Chillida, *Alrededor del vacío III* (Around the Void III), 1965. Steel, 35.5 cm. Photo: Fotógrafos Oronoz. © 2009 Artists Rights Society (ARS), New York / VEGAP, Madrid.

[Freigabe von Orten]" (*GA* 13: 207 / *AS* 5; tm). Giving is the upsurge or the admission into space, or better, the irruption of spacing (the insertion of spacing in a making-room). But as a giving, something must be held back (otherwise there would be unremarked assimilation and, precisely, no giving). The thing in space remains in relation to what gives, it never arrives detached from this. The body in such a space is always arriving, never wholly present. Opened in this manner, what is arriving is arriving here, is arriving as relational. As given, the thing is thereby not only admitted into space but admitted as the open relational entity that it is. Such is the nature of free giving, constituting what Heidegger terms true space (*der wahre Raum*).

The truth (*Wahrheit*) of true space lies in the manner that space presents itself when offered (*gewährt*) under the auspices of a preserving (*Verwahren*). "In this twofold making-room," Heidegger writes, "the yielding [Gewährnis] of places happens" (*GA* 13: 207 / *AS* 6). This yielding of places as *Gewährnis* is a matter of the granting, allowing, offering, and affording of places (a matter of *gewähren*). Insofar as each place is relationally defined through its connections (and disconnections) with other places, places form what Heidegger terms a region (*Gegend*). The spacing apart of things thus maintains a loose and elastic connection between them, and as a result spacing is likewise a "gathering." By means of this region, Heidegger writes, "openness is held to letting each thing emerge in its resting in itself. This means, however, at the same time: preserving [Verwahren], the gathering of the things in their belonging together" (*GA* 13: 207–8 / *AS* 6; tm). Things emerge in space as belonging together. In so appearing, they are not only gathered to one another along the lines of relation and suspended in their emergence in the world, surfacing in the world, buoyed up into the world; they likewise participate in the holding

up and buoyancy of others by permeating the medium that surrounds them.[8] This happens as a safekeeping (*Verwahren*), a bringing of the thing into the custody of the world. Only things opened to the world in this way—that is, contextually defined things—can be kept safe. Only when so utterly exposed would they require safekeeping.

The truth of being (*Wahrheit des Seins*) is precisely this manner of exposed appearing. The true (*das Wahre*) is what so appears. Art becomes for Heidegger "the bringing-into-the-work of truth" (*GA* 13: 206 / *AS* 5), the bringing to it of a preservative safekeeping that yields it place within a contextual whole. Sculpture is only possible as truth, so understood: "Sculpture: the embodiment of the truth of being in its work of instituting places" (*GA* 13: 210 / *AS* 8). This embodiment sets space into its outward rhythm, while resonating through the sculpture itself. Embodiment becomes a matter of moving out. When Heidegger discusses the "place seeking and place forming characteristics of sculptured embodiment" (*GA* 13: 209 / *AS* 7), it is hard not to imagine sculptures like Chillida's *Alrededor del vacío III* (Around the Void III), the thick extruded beams of which slowly bend their way through space, as though searching for something or someone—as though searching for us.

No Means of Production

Petzet mentions the sculptures that he and Heidegger discussed during the course of their conversations. These were all works of iron by Chillida—*Wind Comb, Praise of Air, Around the Void, Música callada* (Silent Music), *Music of the Spheres,* and *Dream Anvil*[9]—works evincing a transformed craft knowledge and craft production that aligns these sculptures within a tradition of Basque ironworking.[10] Chillida trained at the forge of a village blacksmith, where his first iron sculptures were created. The prongs and hooks that these ironworks display at times call to mind strange farming implements, scythes and rakes, prods and harrows. The resonance is not accidental. According to one commentator, Chillida "understands himself first of all as a craftsman [Handwerker]";[11] if this is the case then he understands himself as a peculiar craftsman who poetizes his own craft.[12] In works like the *Dream Anvil* series,[13] the very means of production become works of art, transforming traditional conceptions of both work and sculptor, as well as transforming the notion of the tool interposed between them.

If we consider God as sculptor, as Heidegger presented it in 1927, divine creation is evinced not only by the fact that God creates *ex nihilo*, with no pregiven material, but also directly, without the use of tools. Humans, on the other hand, are abandoned to their tools in order to bridge the nothingness between themselves and their present materials. The idea of the tool is grounded in this implicit void between artist and material that stands in need of bridging. But it is precisely this emptiness that Heidegger sees as fostering the assault of the body upon space. There is no preparation for the arrival of the body, it can only appear as rudely forced, a violation. Heidegger thinks instead the ways in which the body already inhabits the space beyond

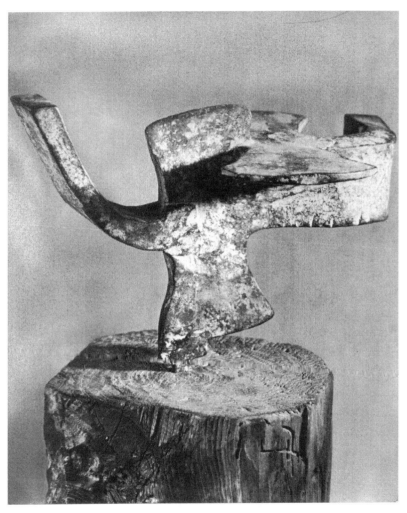

FIGURE 4.3 Eduardo Chillida, *Yunque de sueños II* (Dream Anvil II), 1954–58. Iron and wood, 66 cm. Photo: Galerie Maeght, Paris. © 2009 Artists Rights Society (ARS), New York / VEGAP, Madrid.

its bounds, the way it bleeds into the world as a relational and contextual entity. For this reason there is no emptiness or void, as Heidegger makes clear in his consideration of the empty (*das Leere*) as a manner of gathering (*lesen*): "To empty a glass means: To gather the glass, as that which can contain something, into its having been freed [sein Freigewordenes versammeln]. To empty the collected [aufgelesene] fruit into a basket means: To prepare for them this place. The empty is not nothing. It is also no lack. In plastic embodiment the empty is at play in the manner of a searching-projecting instituting of places" (*GA* 13: 209 / *AS* 7; tm). The examples present a certain economy of exchange. In emptying the glass, the glass is gathered to itself as vessel. In emptying the fruit, the basket is prepared. The entry of the fruit is the preparing, the drinking of the wine is the gathering. Gathering and preparing describe the coursing of what flows from place to place, in a departure that gathers and an arriving that prepares. Such is the relationality of place.

But this would mean that emptiness is never empty, that there is no void (as Chillida seems to have learned). Without a void, how would things occupy their places? They would not *occupy* them, they would *be* those places: "We would have to learn to recognize that things themselves are places and do not merely belong to a place" (*GA* 13: 208 / *AS* 6). Things are particularly concentrated places, knots of space, thickened, poetic places (*verdichtete Orte*).[14]

What are the consequences of this thinking of emptiness for the artwork? It effects a transformation in the notion of tool. If the artist is no longer separated from the world by a divide, if there is no longer the confrontation with a recalcitrant material, but instead some manner of mutual interpenetration, then the idea of the tool as literally a stopgap measure for bridging such divides must be abandoned. Thought on the basis of presence and absence, and

despite all appearances, the tool provided direct access to a removed world. If there is only one mediator there is no mediation (mediation takes four, or two, but never three). Mediation is not a matter of interposition between two otherwise present parties. Mediation is the fact that nothing is present, everything is given, and everything leaks and bleeds outside itself, as participation in a medium (*Lichtung*, *Element*). Heidegger's later thought removes the ecstatic privilege from Dasein and sees it as integral to all appearing whatsoever. Nothing remains within its bounds. The limit becomes a site of encounter and transformation.

The artist would be no artist at all if he or she were to work on an opposed reality. The creativity of the artist cannot be channeled through tools that would otherwise remain unaffected in the process (tool as interposed). The artist does not employ tools as means to an end, where the end would be the artwork and the means completely ancillary to the production. If there is to be mediation, the tool itself can no longer function as intermediary but must itself be transformed. Chillida's ironworks do just this.[15]

Setting Bringing Collaborating

One of the explicit differences between "Art and Space" and "The Origin of the Work of Art," Heidegger's essay some thirty years earlier, concerns the relation of the work to truth. In the earlier essay, Heidegger pronounces the essence of art to be "the setting-into-the-work of truth" (*GA* 5: 21 / 16; tm), while "Art and Space" names it "the bringing-into-the-work of truth" (*GA* 13: 206 / *AS* 5), a change from setting to bringing. While the 1960 "Appendix" ("Zusatz") to the artwork essay is at great pains to defend the earlier language of "setting" from Heidegger's own later consideration of *setzen* (setting) and *stellen* (placing) as key players in the technological reign of *Ge-stell* ("positionality" or "enframing"), he nevertheless includes a note to the "Appendix" at the first mention of truth as "setting-into-the-work," which reads "better: bringing-into-the-work; bringing-forth, bringing as letting; ποίησις [*poiēsis*]" (*GA* 5: 70, n. a / 5, n. a).[16]

The term *setting* includes a sense of imposition (*setzen* could equally be translated as "positing"), an action by force. Setting also implies a sense of control over what is set up. The one who sets something in place puts it there from a position of control. In the word *bringing* the emphasis falls more on accompaniment. I bring something "with" me. According to what I "bring" to the table versus what I "put" on the table, two different relationships are struck. Bringing does not entail the finality of what is "put" or "set." What is set in place is set with an eye toward its fixity (precisely what Heidegger tries to play down in the "Appendix," before undermining his own argument with the note proposing *bringing* as the better term). Rather than remaining fixed, what is brought is let loose at the destination, to be taken up, shared. My control over what is brought is limited. When I bring a friend or a bottle of wine

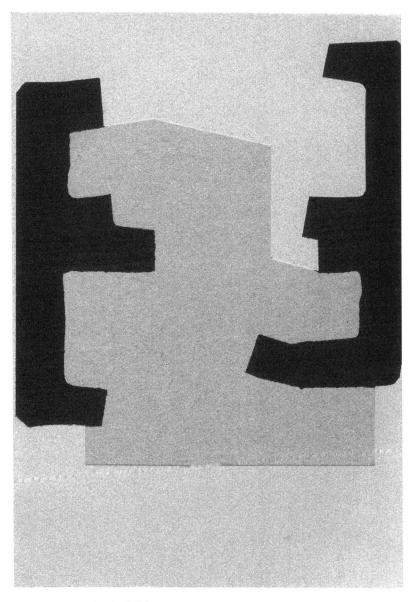

FIGURE 4.4 Eduardo Chillida, *Die Kunst und der Raum*, no. 4, 1969. Lithocollage, 21.5 cm. × 15.5 cm. Photo: Image Bank VEGAP. © 2009 Artists Rights Society (ARS), New York / VEGAP, Madrid.

FIGURE 4.5 Eduardo Chillida, *Die Kunst und der Raum*, no. 2, 1969. Lithocollage, 15.5 cm. × 21.5 cm. Photo: Image Bank VEGAP. © 2009 Artists Rights Society (ARS), New York / VEGAP, Madrid.

to a party, both are out of my hands to mingle and be shared as the case may be. In "Art and Space," then, truth arrives in the work less insistently than in "The Origin of the Work of Art."

Art and Space itself is a collaboration between Heidegger and Chillida, the book belongs to neither of them alone. It already entails a certain surrender of mastery over the product. It would appear to be no accident that the text promoting a conception of bodily spatiality as relationally extending through and filling a never empty space would be collaboratively accompanied by the work of an artist who conceives his contribution in sculptural terms, if not as a collection of paper sculptures. In the interview with Ugalde, Chillida calls these lithocollages a form of "sculptural commentary" on Heidegger's text.[17] These works consist of glued paper figures atop a lithographic print, rising up from the page and equally subject to gravity pulling them down. As Chillida elsewhere remarks concerning his lithocollages of the period, "even without a big weight, even the most thin paper is always connected with gravity."[18] In short, and as Chillida claims in his conversation with Ugalde, he "wanted the illustrations to be in relief."[19]

Sculpture shapes the space of collaboration. Collaboration could not take place across any other kind of space, it cannot happen across a void. For Chillida it was important that Heidegger's text be "written in gothic characters from his bare hand, from the flexion of his pen, from the space of his handwriting," that they embark upon this stone together.[20] Participation requires a medium, an ever-developing, dense, or thickened space (*verdichtete Raum*), like the Bavarian Solnhofen stone upon which Heidegger wrote his text and Chillida composed his lithocollages.[21] Only such a thickened medium can permit the community and communication of collaboration.

A medium can never mediate between two completely isolated parties, the parties must already be open to relation. In a sense, then, collaboration requires no medium, where this is still thought as a means or a tool. Collaboration can only happen between two bodies where each is already spatially distributed (mediated).[22]

The collage component builds up from the lithograph, converting a two-dimensional space into a three-dimensional one. As a youth, Chillida considered a career as a professional soccer player, and his experiences find their way into his thinking of this three-dimensional sculptural spatiality:

> There are a lot of connections between football and sculpture. The conditions you need to be a good goalkeeper are exactly the same as the conditions you need to be a good sculptor. You must have a very good connection, in both professions, with time and space. . . . The field of football is a two-dimensional space, but this two-dimensional space becomes, in goal, three-dimensional. This is the space for the goalkeeper and this is the place where the ball is more active, always. Everything happens there. And the problems of time become very hard, much more than in any other place in the field.[23]

Chillida's lithocollages present strange fields for other games and collaborations, for what we too easily refer to as "teamwork." The artist has truth on his or her team. We do not set truth into the work, as though we would control it. Best for us is to accompany truth, team up with it, and in so doing let truth itself bring us to the work.

Articulation 3: Preparation for Dwelling

Truth does not just happen; it must be sheltered and preserved. This requires that the human refrain from the occupying seizure of space or from enclosing it as a possession. The truth of being requires our collaboration. It requires that the human be out beyond itself as well, in a mutual belonging to the world, concomitant with our apparent emergence and immersion in the world. The nature of that collaboration for Heidegger is a dwelling. This emphasis upon dwelling, however, may lead us to suspect Heidegger of a certain anthropocentrism, for lack of a better term, as when we read that the truth relations of sculpture would be in the service of human dwelling: "Sculpture would be the embodiment of places, opening a region and preserving it [sie verwahrend], holding a free area gathered around it which affords [gewährt] a tarrying to the respective things and a dwelling to the humans in the midst of things" (GA 13: 208 / AS 7; tm). The charge of anthropocentrism would seem to receive its most poignant confirmation at the moment when Heidegger traces the meaning of space (Raum) back to spacing (Räumen) and then goes on to explain the meaning of such spacing: "This means to clear out [roden], to free from wilderness [die Wildnis freimachen]. Spacing brings forth the free, the opening for the settling and dwelling of humans. . . . Spacing brings about a location [Ortschaft] that is each time preparatory for a dwelling" (GA 13: 206 / AS 5; tm, em). Spacing frees up the wild ground for human settlement, spacing is the preparation for such dwelling, and space itself prepares for our settlement and clearing away of the wilderness.

But before we rush to pronounce Heidegger an ontological Manifest Destinarian or some bizarre form of antienvironmentalist, we should first further consider our own place in the world. As admitted into space, as here in this

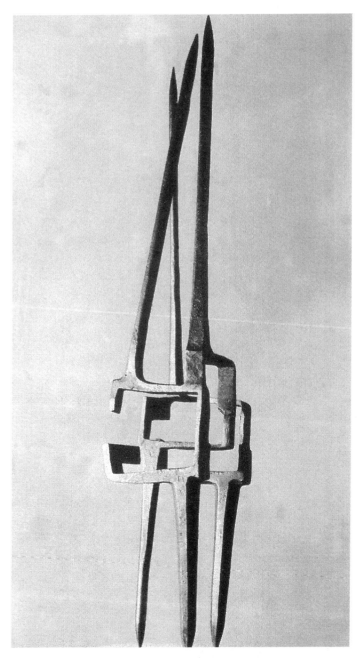

FIGURE 4.6 Eduardo Chillida, *Elogio del aire* (In Praise of Air), 1956. Iron, 132 cm. Photo by Walter Dräyer, courtesy of the Carnegie Museum of Art, Pittsburgh. © 2009 Artists Rights Society (ARS), New York / VEGAP, Madrid.

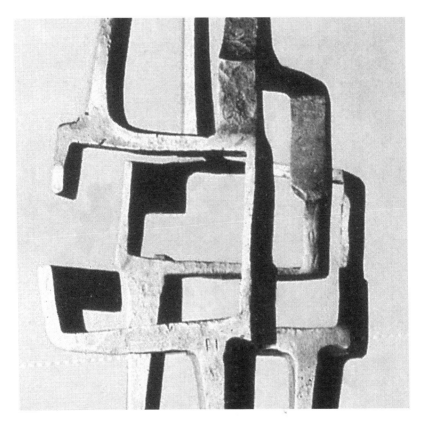

FIGURE 4.7 Eduardo Chillida, Detail of *Elogio del aire* (In Praise of Air). Photo by Walter Dräyer, courtesy of the Carnegie Museum of Art, Pittsburgh. © 2009 Artists Rights Society (ARS), New York / VEGAP, Madrid.

region amid these places, I, too, am already in communication with and in commerce with them. I dissolve into them. I am of the world, inextricable from it; I radiate through it. For this reason, spacing is termed a preparation, because we are already there amid this purportedly "empty" space ahead of ourselves. For this reason it is preparatory for a dwelling, for if there is to be a dwelling for humans at all, it must be amid and between the things and others of the world. Chillida thinks this "between" in terms of the horizon lying between earth and sky: "Horizon is very important to me, it always has been. All men are equal and at the horizon we are all brothers, the horizon is a common homeland."[24] Relationality is *absolute*, it cannot exclude humans. The world is already prepared for us because we are the world. But we do not only encounter ourselves, we encounter others with ourselves. Alterity and the wilderness are only cleared away to the extent that they are no longer viewed as without relation to me. They become part of a region of relations and they can now claim me. "Sculpture: an embodying bringing-into-the-work of places, and with them an opening of regions of possible human dwelling, regions of the possible tarrying of things surrounding and approaching the human" (*GA* 13: 209 / *AS* 8; tm). The wilderness can only be a concern for me if it can reach me, and it can only reach me, if we both participate in the unelected yet affinitive play of spacing. Only in this freeing of the wilderness can we belong to it and be claimed by it.[25]

But it is important to note that we are not the only participants here. These places are also the sites "at which a God appears, the places from which the Gods have flown, places at which the appearing of the divine has long hesitated" (*GA* 13: 206 / *AS* 5; tm). They are places of "fate" and "destiny" (*Schicksal*), places of the wild, the inhuman, the divine. Human dwelling is always

exposed to the inhuman and the extrahuman, is always an encounter with the unknown other. The "place seeking and place forming characteristics of sculptured embodiment" (*GA* 13: 209 /*AS* 7) can be a "seeking" only because this embodiment does not possess what it searches for but is open to its arriving, is displayed before the unexpected. It searches because it does not know. Chillida said, again in 1967:

> When I begin I have no idea where I'm going. All I can see is a certain spatial constellation from which lines of strength gradually emerge. A direction makes itself felt; and sometimes it leads me where I have never penetrated before, compels me to take first one new direction, and then another—both equally unexpected. I always trust to instinct, the feeling for plastic which I feel within me. At first this feeling is barely perceptible, but as it grows clearer it becomes all the more compelling. I am pursuing a path; I perceive something that I call, for want of a more appropriate word, the "emanation" of a form; I gradually absorb it and as it were inhale it.[26]

The emanation of form not only prepares the space for our arrival but prepares us for the arrival of the thing as well. We are able to dwell because we are already permeated by these places and things.

Space, My Interlocutor

"Art and Space" opens and closes with an epigram from Lichtenberg and a citation from Goethe. Bounded by these poetic references beyond its own pages, the text employs etymology to further prod the thinking of space.[27] This emphasis on language for a thinking of space is not accidental. "Art and Space" leads us to think a twofold: that space would be intelligible and language spatial. Lichtenberg's proverb gets us underway toward thinking this strange unity: "If one thinks much, one finds much wisdom inscribed in language. Indeed, it is not probable that one brings everything into it by oneself; rather, much wisdom actually lies therein, as in proverbs" (*GA* 13: 203 /*AS* 3; tm). There is wisdom in language apart from what we have brought into it. We are not its masters. But there is also wisdom in language that *we have* brought into it. Language commingles these wisdoms. Language itself becomes a site of communion (or communication), like space. As the medium of appearing, space is always a sensible and meaningful medium—what appears makes sense[28]— while the language that comes to speak in this commingling is a language of distance, arising from the namelessness of relationality itself.

When things lose the discreteness of their boundaries, they no longer function as the referents to an appellation; they enter the nameless. In regard to such things that can no longer be thought of as "volumes," Heidegger writes: "Volume will no longer delimit spaces from one another, in which surfaces surround an inner opposed to an outer. What is named by the word 'volume,' the meaning of which is only as old as modern technological natural science, would have to lose its name. The place seeking and place forming characteristics of plastic embodiment would first remain nameless" (*GA* 13: 209 /*AS* 7; tm). Like the wilderness, namelessness prepares for a naming. The silence of

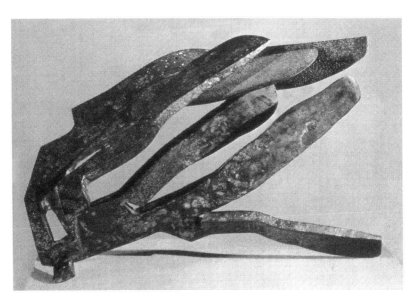

FIGURE 4.8 Eduardo Chillida, *Peine del viento II* (Wind Comb II), 1959. Iron, 50 cm. Photo by Walter Dräyer, courtesy of the Carnegie Museum of Art, Pittsburgh. © 2009 Artists Rights Society (ARS), New York / VEGAP, Madrid.

space is already populated by sense (where else would the language that the human does not "have" *be*?). The naming of the thing is prepared by the density of this medium of appearing, a medium so thick and fibrous that we might even comb it, if we only knew how. But naming is not a doling out of titles.[29] It does not reach across to something completely unknown to domesticate it. Naming suffers the unknown, affiliates it. Naming is a calling out that brings near, a reverberation of the medium that pulses out and washes back. Naming welcomes, it lets the thing exceed itself and thus retain its distance from us. These names allow things the distances necessary for reaching us. Poetic naming, in sum, effects a spacing, only ever names a relationship. It can only do so because language is already out beyond the mortal (no possession of the *zōon logon echon* [ζῷον λόγον ἔχον], the animal having reason), preparing the intelligibility of all appearing and blowing through space.

In thinking through Chillida, Heidegger tries to think space itself as middle ground and medium. To think space on its own (*in sein Eigenes; GA 13: 206 / AS 5; tm*) by no means supposes that Heidegger leaves the body behind, but instead, more transfiguratively, that the body is no longer anything separable from space: "things themselves are places and do not merely belong to a place" (*GA 13: 208 / AS 6*). Space is not derived from anything prior to it, "behind space, so it will appear, nothing more is given to which it could be traced back. Before space there is no retreat to something else" (*GA 13: 205 / AS 4*)—not even to bodies.

But this is not to say that space is ever apart from bodies, despite appearances Heidegger might give to the contrary. To think space itself is to think bodies, though no longer as contained by volumes. To think space itself is to think this populated middle place of sensible appearing. To be sure, the cita-

tion from Goethe that closes the text is offered in support of the claim that "even a cautious insight into the special character of this art [sculpture] lets one suspect that truth, as unconcealment of being, is not necessarily dependant on embodiment [nicht notwendig auf Verkörperung angewiesen ist]" (*GA* 13: 210/*AS* 8). It reads: "Goethe says: 'It is not always necessary that what is true embody itself; it is already enough if spiritually it hovers about and evokes harmony, if it floats through the air like the solemn and friendly sound of a bell'" (*GA* 13: 210/*AS* 8). Truth, then, is not necessarily a matter of embodiment. As has been shown, what appears when sheltered is "true." This is not always a body but is always in a medium (even if only that through which spreads our sheltering concern). Consequently, to think space apart from bodies is not to give up on embodiment but to think the body as no longer distinct or separable from space, to think the body as dissolved in space yet defined by it, as mediated, an inhabitant of the between, neither present nor absent but always arriving sensibly and shining out beyond itself through space. To think space itself is to think the middle, the between. Space is the truth, the space through which, as Goethe says, what is true resounds, not as raw noise but like a bell, that is, as something rippling through a medium. The truth of sculpture is the truth of being: mediation.

Conclusion

THE TASTE OF US

Sculpture is a matter of articulation, the art of limits. But rather than circumscribing a completed work, articulation is a way of remaining incomplete. The articulated body is not self-standing; it transpires with its environs, it marks and is marked by what is other to it. Sculpture stages this fact of exposure, of incompletion as belonging to a world. Each of the sculptors with whom Heidegger concerns himself explores this fact. The degeneracy of Barlach's sculpture lies in the formlessness that literally informs his work. The well-defined faces and hands of these sculptures emerge from the incomprehensible and unexplored masses at their heart. Barlach's work shows the formless other that inhabits every body, our own included, and gives us to understand that even the exposure of existence would be impossible without this unshaped material earthliness. Heiliger's sculpture records the struggle of existing in a world beyond ourselves that is never empty or void but that operates with a material force to weather and wear us down. The decaying effects of exposure reveal exteriority to be ever entering us, riveting through us, exiting us, and drawing us out of ourselves, making the outside a part of us. Chillida begins with a conception of form as always emanating beyond itself, with sculptures that not only echo and reverberate a silent music but that invite the medium to blow across their surfaces as well. Chillida and Heidegger agree in finding this middle ground, this "between," to be the only possible site for a dwelling that is particularly human—that is, relational and tied to surrounding people, places, and things. Such a connection is even more evident in the receding and supportive empty space of sculpted reliefs, such as the Athena reliefs discussed earlier, and it is no coincidence that each of these three sculptors also worked in relief.

Sculpture stages a respiration between body and world. The space of sculpture differs from the space of the everyday world of traffic and com-

merce, conducting our thought along different paths and slowing all movement from point *a* to point *b*. Sculpture thickens space, gathers it together and knots it in ways that are felt throughout its surroundings. The sculptural bending of space warps our intentions away from their targets to trail off indefinitely, leaving us behind, unsatisfied and exposed before the work. We fail ourselves before the work and fall exhausted before its radiance. Sculpture is a testament to exposure, to the fact that *we are dissolving in space*. The work runs through us and carries us along with it. Our concerns extend beyond ourselves, our bodies do not end at our skin, our bodies are beyond ourselves, our concerns make up our skin. There is nothing but skin for such a disorganized (nonutilitarian) body, skin understood as surface of sense, as unfurling sheets of sheer phenomenality. We so fully belong to this world that it bears our scent, our taste, we dissolve into it and soften the edges of dwelling. Sculpture reveals to us our inextricable belonging to world.

Such a space is far from empty. All that appears participates in this space and is drawn out by it. All that appears lends space its weight. There is no frictionless or lossless space. It abrases us and weathers us. We are weathered by exposure. *We are dissolving in space*. The concerns of the body ripple through this medium, formulated by it, never-ending into it. The metaphysical conception of space as void—this too is nonetheless nothing alien to the mediality of space (and it should be clear by now that there is nothing alien to the mediality of space; we are "prepared" for everything). Such conceptions only serve to vary still more the tensions of space, furthering the conditions of its material conducting.

The world flows through us and buoys us along, ebbing and flowing, drawing us out and relating back to us. Such a rhythmic emanation is definitive of

place. The withdrawal of being that opens place (a withdrawal that *needs* to be mistaken for void), that lets place be a matter of relation, reverberates through these places, unsettling them. These reverberations of place echo through us, too, as rhythm.[1] Rhythm, Heidegger claims, is "the relation bearing human beings" (*GA* 13: 227); by undulating through us it sways us further into the world. Rhythm can overtake us. Sculpture syncopates the world. Sculpture is the art of spatial rhythm which seeks us out and enters us, attuning us to its sinuous invitation: that we dwell here in the midst of its radiance.

But if sculpture lures us out of ourselves by entering into us, if it interrupts our doings by a thickening of space that allows its rhythm to take hold, then it does so only to reveal to us our mediality, that we exist outside ourselves to such an extent that we are the world. Things plunge into this abyss of the world, they shine in their appearing, streaking by as they fall. Everything falls and runs past its borders (*panta rhei*; πάντα ῥεῖ). Sculpture reveals to us our mediality by making visible the invisible (world). Every sculpture performs this impossible task differently. Sculpture is the articulation of being, appealing to us that we change our bearing in the world, that we dwell, *that we change our life.*

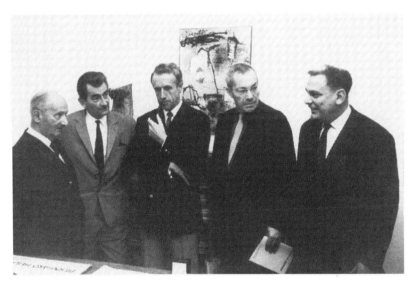

FIGURE 5.1 Martin Heidegger, Günther Neske, Bernhard Heiliger, Max Bill, and Franz Larese at the Erker-Galerie, St. Gallen, Switzerland, for the opening of the Heiliger exhibition, 3 October 1964. Photo courtesy of the Bernhard Heiliger Stiftung.

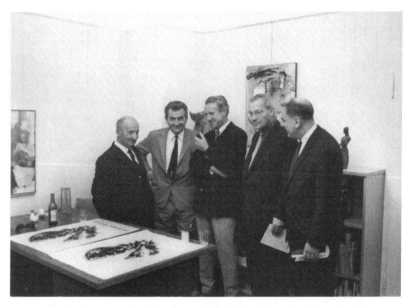

FIGURE 5.2 Martin Heidegger, Günther Neske, Bernhard Heiliger, Max Bill, and Franz Larese at the Erker-Galerie for the opening of the Heiliger exhibition, 1964. Photo courtesy of the Foto-Archiv der Erker-Galerie, St. Gallen, Switzerland.

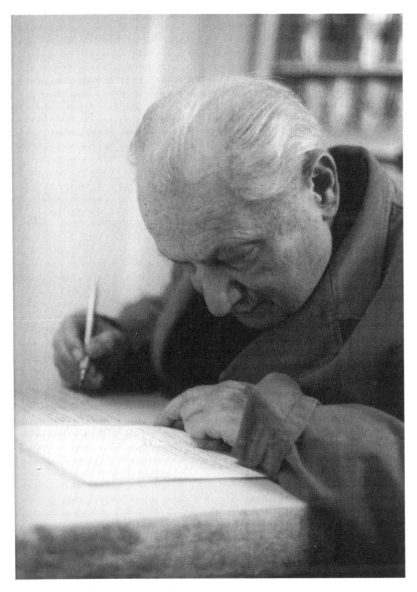

FIGURE 5.3 Martin Heidegger writing the text "Die Kunst und der Raum" on stone at Erker-Presse, St. Gallen, Switzerland, 1969. Photo courtesy of the Foto-Archiv der Erker-Galerie, St. Gallen, Switzerland.

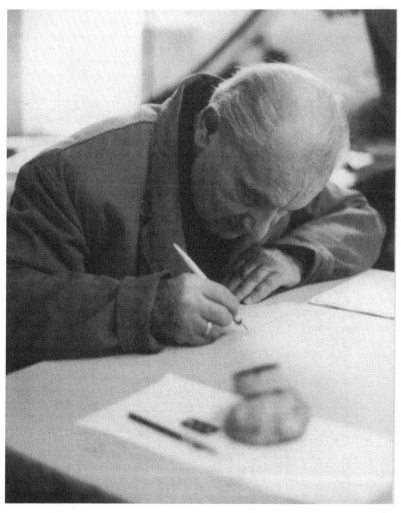

FIGURE 5.4 Martin Heidegger writing the text "Die Kunst und der Raum" on stone at Erker-Presse, 1969. Photo courtesy of the Foto-Archiv der Erker-Galerie, St. Gallen, Switzerland.

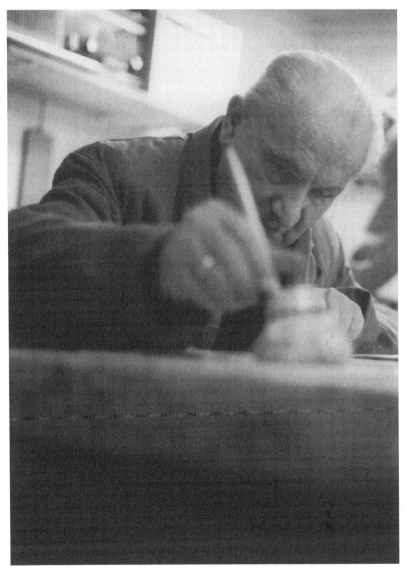

FIGURE 5.5 Martin Heidegger writing the text "Die Kunst und der Raum" on stone at Erker-Presse, 1969. Photo courtesy of the Foto-Archiv der Erker-Galerie, St. Gallen, Switzerland.

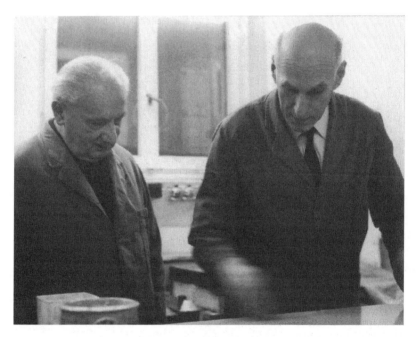

FIGURE 5.6 Martin Heidegger with the printer August Bühler, working on "Die Kunst und der Raum" at Erker-Presse, 1969. Photo courtesy of the Foto-Archiv der Erker-Galerie, St. Gallen, Switzerland.

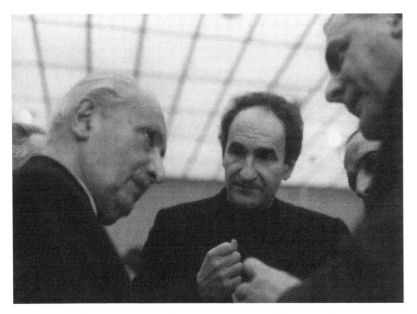

FIGURE 5.7 Martin Heidegger, Eduardo Chillida, and Franz Larese at the Kunsthaus, Zürich, Switzerland, 1969. Photo courtesy of the Foto-Archiv der Erker-Galerie, St. Gallen, Switzerland.

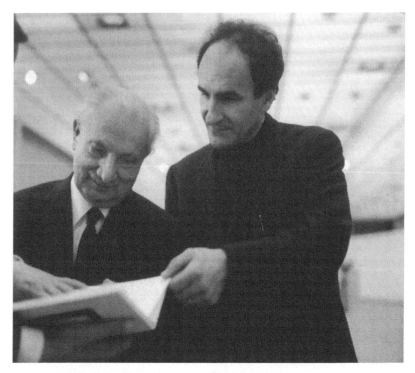

FIGURE 5.8 Martin Heidegger and Eduardo Chillida looking over *Die Kunst und der Raum* at the Kunsthaus, 1969. Photo courtesy of the Foto-Archiv der Erker-Galerie, St. Gallen, Switzerland.

Notes

Introduction

1. Though it must be born in mind that Heidegger in these writings is focusing on one particular medium of art, sculpture, rather than art as such, a point noted by Seubold, *Kunst als Enteignis*, 57. On the revision to the artwork's role in truth, see "Setting Bringing Collaborating," 78–82 below.

2. Existing work on Heidegger and space includes Casey, *Fate of Place*; Elden, *Mapping the Present*; Vallega, *Heidegger and the Issue of Space*; and Malpas, *Heidegger's Topology*. Works on Heidegger's thinking of art include Kockelmans, *Heidegger on Art and Art Works*; and Young, *Heidegger's Philosophy of Art*. A recent book on the body in Heidegger is Schalow, *Incarnality of Being*. The three books listed here on art and the body do not address Heidegger's later theories of art or sculpture (Heidegger's essay "Art and Space," perhaps the central document of his later aesthetics, has been available in English translation since 1973). The topic fares better in the works on space, with "Art and Space" at least receiving limited treatment. Even here, though, the later essay is enlisted to confirm conclusions already established with reference to Heidegger's earlier works. (Malpas and Elden are the exceptions, recognizing a more original role for the essay.) Heidegger's "Remarks on Art—Sculpture—Space" is not treated in these works (available in German since 1996), nor is the history of Heidegger's repeated engagements with sculpture discussed or recognized in the literature (the Barlach essay is fully ignored). Such limited attention is by no means a fault in these works and the success of their arguments does not hinge on it. A welcome addition to the literature is Crowther's "Space, Place, and Sculpture."

3. Malpas provides the most thorough treatment of the space/world tension. As he notes, "Heidegger often seems to be pulled in two different directions: on the one hand, he recognizes the inevitability of spatiality as part of the structure of being-there and so insists on being-there as having spatiality proper to it, while, on the other, he constantly seeks to deemphasize the role of spatiality and to stress that it cannot be a primary notion in the analysis of being-there" (*Heidegger's Topology*, 79). The issue is provocatively developed at length in chapter 3 of his book.

4. Most prominently in "Geschlecht I."

5. Such places arise from the belonging of the equipment and participate in a

larger equipmental context that Heidegger terms a "region." Casey provides a thorough account of this in his magisterial *Fate of Place*, esp. 247–56.

6. Vallega is able to pursue a course of interpreting space in *Being and Time* in terms of "alterity" and "exile" in his *Heidegger and the Issue of Space*; see esp. chaps. 2 and 4.

Chapter 1: Ernst Barlach

1. Friedrich Hildebrandt, speech of 16 February 1934, recorded in the *Lübecker General Anzeiger* (Lübeck General Gazette) of 18 February 1934 and cited in Paret, *Artist Against the Third Reich*, 81, reprinted in Piper, *Ernst Barlach*, 104.

2. An office held at the time by one Hans Schweitzer. Schweitzer is perhaps better known as the Nazi poster artist Mjölnir, responsible for many of the iconic images of the Reich. See Paret, *Artist Against the Third Reich*, 99.

3. For a fuller description of the intimidation and censorship that Barlach suffered and resisted after the Nazi rise to power, see the aptly titled chapter 4 of Paret, *Artist Against the Third Reich*, "The Hounding of Barlach," 77–107, as well as 125–37.

4. For the catalog of the exhibit, see Kulturverwaltung der Stadt Darmstadt, *Ernst Barlach*. The gallery exhibition was accompanied by a performance of Barlach's play *The Count of Ratzenburg*. Petzet records Heidegger's concerns over the Barlach performance: "Then we talked about Barlach's *Ratzenburg*, which was performed in Darmstadt. Heidegger: "This won't work. Young people do not listen. Vietta deceives himself, and Sellner [a coproducer of the event]—despite recognition of his intellectual accomplishment—is dragged into the 'current operation' (*Betrieb*). . . . This whole thing does not make sense" (*ASZ* 85 /78). Further details about Vietta's relationship to and advocacy for Heidegger can be found in *ASZ* 107–10 /100–102.

5. Barlach's cenotaph to the war dead in Hamburg that had been sequestered and subsequently destroyed by the Nazis in 1938 had been reconstructed and was restored to its original location just two years earlier in 1949. The restoration occurred against numerous objections in the press. Some are careful to explain that their position against Barlach had nothing to do with politics, others argue that the artistic enemies of the Nazis are not necessarily to be received now as heroes (for the debate as a whole see Piper, *Ernst Barlach*, 247–55; the restoration of the Magdeburg Memorial received similar reactions). As one writer to the *Hamburger Allgemeine Zeitung* (Hamburg Public

Newspaper) expressed it in 1949, "No one will be able to proclaim that the figure still standing in our memory represents a German woman and mother, but instead one indeed has the impression, with all due tolerance to alternate conceptions of art, that one has before oneself here an underground figure of degenerate art" (209). Another 1951 retrospective in East Berlin, East Germany, likewise raised objections against Barlach, this time as an "antihumanist" (256; for further reactions see 256–61).

6. Vietta's introduction to Heidegger's text explicitly dates it as "stemming from an unpublished work of Martin Heidegger's from the years of 1939–40, the beginning of the Second World War" (*EB* 5). This was published again in slightly revised form as § 26 of "Overcoming Metaphysics," in Heidegger's *Vorträge und Aufsätze* of 1954 (*GA* 7: 90–96 /*EP* 103–9). A marginal note at the head of this section in the text adopted into the *Gesamtausgabe* likewise dates it to 1939–40 (*GA* 7: 90, n. i).

7. Insufficiency, not as any deprivation, as though an outstanding part would be lacking, but etymologically, relating back to the Latin *sufficère, sub- + facère*, to make or do. Thus the "insufficiency of beings" should call to mind instead the ways in which beings elude, escape, and exceed the finishedness of the *ens creatum*. See *The Oxford English Dictionary*, 2nd ed., s.v. "insufficiency."

8. Barlach to Karl Barlach, Güstrow in Mecklenburg, 20 May 1916. In Barlach, *Leben und Werk*, 88. Also cited in Gross, *Zur Seinserfahrung*, 45.

9. Heidegger says as much in the 1953 Trakl reading, "Language in the Poem: A Discussion of Georg Trakl's Poetic Work," in a discussion of *Geschlecht* (clan, tribe, race, sex, generation, kind). Here, the discussion revolves around a humanity that has been struck by a curse sending it into an opposition of discord (*Zwietracht*). "The curse . . . is that the old human kinship has been struck apart by discord among sexes, tribes and races. . . . Not duality as such, the discord is the curse. Out of the turmoil of blind wildness it carries each kind into an irreconcilable split, and so casts it into unbridled isolation" (*GA* 12: 46 /*OWL* 170–71). Heidegger is consequently not objecting to difference or dualism (*das Zwiefache*), but to a duality that would be antagonistically opposed, as per the oppositions of metaphysics. The appeasement of such discord is not found in the annihilation of one of the parties, but instead is only found "with that kind whose duality leaves discord behind and leads the way . . . into the gentleness of simple twofoldness" (*GA* 12: 46 /*OWL* 171). To delve any further into the complicated

relations of *Geschlecht* would take us too far afield of our present concerns, the place of sculpture.

10. Cited in Piper, *Ernst Barlach*, 61–62.

11. Piper, *Ernst Barlach*, 84.

12. As Kurt Lothar Tank, author of *Deutsche Plastik unserer Zeit* (1942), an anthology of National Socialist–approved sculpture, puts it, "Form-bestowal means meaning-bestowal [Formgebung bedeutet Sinngebung]" (101). The volume culminates in the concluding chapter, "Mission and Fulfillment," a treatment of the work of Thorak and Breker as epitomizing the monumental sculptural style expressive of a people. It is a style of unlimited formative power, as in Thorak: "The energy of this man and the scope of his creation is wondrous, encompassing the portraits, violent animal sculptures, male and female figures, and every part betrays a great and healthy conception of form" (105), a style that encompasses the figure, as in Breker: "Where this contact succeeds [of seeming oppositions like war and art, power and spirit, state and nature], as intensely as it does in Breker's creation, then there is no inanimate surface, there the hand, even the finger, is sinewy and tense, there the taut muscles are laid bare, there the gaze is fixedly directed at a goal" (112). In short, it is everything that Barlach is not.

13. The connection between health and classical beauty is clearly stated in Hitler's speech at the opening of the *Haus der deutschen Kunst* (18 July 1937):

Today the new age is shaping a new human being. In countless areas of life huge efforts are being made to exalt the people: to make our men, boys, and youths, our girls and women healthier and thus stronger and more beautiful. And from this strength and this beauty there springs a new lease on life, a new joy in life. Never has mankind been closer to antiquity, in appearance or feeling, than it is today. Steeled by sport, by competition, and by mock combat, millions of young bodies now appear to us in a form and a condition that have not been seen and have scarcely been imagined for perhaps a thousand years.

These lines of the speech are reprinted in two key texts on the "degenerate art" of the time, Fritz Kaiser's 1937 exhibition guide to the Degenerate Art exhibit itself (*Entartete "Kunst,"* 26; English translation in Baron, "*Degenerate Art*," 384) and Adolf Dresler's *Deutsche Kunst und Entartete Kunst* from 1938 (28).

14. Barlach, *"Als ich von dem Verbot der Berufsausübung bedroht war"* in *Die Prosa II*, 427–31, 427–28.

15. See *ASZ* 62/56. The lectures in question are the Bremen lecture cycle "Insight into That Which Is," first delivered in Bremen in 1949. Vietta's own contribution to the Barlach catalog, "Attempt at a First Interpretation of 'The Count of Ratzenburg,'" makes repeated mention of the lecture cycle and concludes with a note that "it would be thoroughly possible to bring the work of Barlach into agreement with the terminology of Martin Heidegger, from whom the concept of the 'turning' is borrowed" (*EB* 46). If this is indeed the case, then it would certainly require no longer thinking nearness in terms of "a new presence" and technology as simply "representational" as Vietta does (*EB* 38).

16. Since Heidegger refers to Kuhn as "distinguished with the Goethe-prize of the city of Frankfurt" (*GA* 7: 93/106; tm), an award Kuhn won in 1942, further editing of this section must have taken place after the 1939–40 presumed date of the work's composition.

17. In Helmut Gross's book on Heidegger and Barlach, *Zur Seinserfahrung bei Ernst Barlach*, Gross presents Barlach as seeing "all beings as determined by possibility" (213) and emphasizes the need to bring death into life in order to found "the possibility of the ability-to-be-a-whole of Dasein in authenticity" (206). But while Gross is interested in the form of Barlach's sculpture (in particular, the cruciform works which exemplify for him human co-belonging, "The cruciform is the deepest form into which human co-belonging can be brought" [188]), he does not attend to those less articulated aspects of Barlach's work that I emphasize in the above. He does not connect Dasein's possibility with the inarticulate aspects of Barlach's sculpture, nor with the idea that being a whole would be antithetical to complete formation. I emphasize co-belonging, not in the uniting of opposites within a cross, but in the negotiation between the formed and unformed in the works. It should be noted that for chronological reasons Gross bases his analysis almost wholly on *Being and Time*: "We must here forego a confrontation of Barlach with the late work of Heidegger, since this would no longer be conceivable with the notion of a 'contemporary'" (203, n. 16), while I am under no such stricture.

18. Barlach, *Die Prosa I*, 55. Also cited in Gross, *Zur Seinserfahrung*, 3.

Chapter 2: Bernhard Heiliger

1. In the productive year of 1963, Heiliger completed *Die Flamme* (Flame) in Ernst-Reuter-Platz in Berlin, *Panta rhei* (Everything Flows) as a wall of the Botschaft der Bundesrepublik Deutschland in Paris, and *Auftakt* (Prelude) in the foyer of the Berlin Philharmonic. In 1970, his *Kosmos 70* (Cosmos 70) was installed in the entrance hall of the Reichstag building in Berlin.

2. Without question, the Erker-Galerie in St. Gallen, Switzerland, is the central forum for the later Heidegger's contact with sculpture, sculptors, and contemporary art on the whole. The roles of Franz Larese, co-owner and founder of the gallery, and his brother Dino Larese, author and committed cultural ambassador for the Bodensee region, cannot be overestimated in this respect either. Heidegger notes the duality of their approach in a letter to Elfride from 4 October 1964: "It's a divided affair with these two brothers—on the one hand very interested & solicitous & at the same time vigorously business-minded" (*MLS* 354 /291; tm).

As cofounder of the Erker-Galerie (with his partner Jürg Janett running the press), Franz Larese curated the exhibitions of Heiliger and Chillida that brought Heidegger into contact with these sculptors, as well as the later Erker-Treffen meetings of the early 1970s that introduced him to other graphic artists as well (Heidegger wrote on lithographic stone to accompany prints by Giuseppe Santomaso [Erker Treffen I, 1972] and Wifredo Lam [Erker Treffen II, 1974]). As early as 1960, Heidegger attended the Erker-Galerie opening for an exhibition by the Italian sculptor Giacomo Manzú. Franz Larese also attended a few of Heidegger's 1969 seminar sessions in Le Thor.

Dino Larese, for his part, deepened Heidegger's artistic contacts through the many gatherings, professional and otherwise, that he organized in Amriswil, Hagenwil, and Hauptwil, Switzerland. After the 1960 Manzú exhibition, Dino Larese records his subsequent trip with Heidegger through the village of Hauptwil, one-time home of Hölderlin, in his *Mit Heidegger in Hauptwil*. Heidegger contributed an essay on Adalbert Stifter to the fiftieth birthday Festschrift for Dino Larese in 1964 ("For Dino Larese as thanks for his instigation of the Stifter reading," which may refer to the fact that Heidegger had read this text over Radio Zürich in January of 1964); see Heidegger, "Zur Lesung von A. Stifters 'Eisgeschichte' aus 'Die Mappe meines Urgrossvaters,'" (On the Reading of A. Stifter's "Ice Tale" from "My Great-grandfather's Portfolio")

in Strehler, *Dino Larese zum 50*, 25. The text was later adopted into the *Gesamtausgabe* as "Adalbert Stifters 'Eisgeschichte'" [Adalbert Stifter's "Ice Tale"]; *GA* 13: 185–98). Heidegger also contributed a warm letter of thanks to Dino Larese's sixtieth birthday Festschrift for his arrangement of Heidegger's own eightieth birthday celebration in Hauptwil, an event involving Heidegger's whole family ("a sign of my renewed thanks for the Amriswil /Hagenwil celebration arranged by you with the usual mastery . . . happiness and thanks reigned over so much naturalness and simplicity"; see Heidegger, "Ein Brief von Martin Heidegger" [A Letter from Martin Heidegger] in Strehler, *Dino Larese zum 60*, 53). Dino Larese subsequently included a selection of occasional speeches that Heidegger had made in Switzerland in his edited volume *Philosophen am Bodensee*, 53–74. The encounters with contemporary artists arranged by Franz Larese and the hospitable atmosphere fostered by Dino Larese played a shaping role in Heidegger's concern for sculpture in his later aesthetics.

3. Günther Neske had asked Heidegger in 1963 if he would like to participate in a manuscript display at Dokumenta III, which he declined, as he explains to Elfride in a letter from 20 November 1963: "Likewise with the plan for exhibiting various authors' mss next year at Dokumenta III in Kassel—could I put the ms of B. & T. at his disposal? I said no. He goes more & more for the 'wilfully modern'" (*MLS* 349 /287).

4. Heidegger understands the human of such a public as a body that "has a soul, in whose interior course experiences as a stream of experiences" (*KPR* 12).

5. Compare "Building Dwelling Thinking," of 1951, where a similar point is made: "When I go toward the door of the lecture hall, I am already there and I could not go to it at all if I were not such that I am there. I am never here only, as this encapsulated body; rather I am there, that is, I already pervade the room, and only thus can I go through it [d.h. den Raum schon durchstehend, und nur so kann ich ihn durchgehen]" (*GA* 7: 159 /*PLT* 157).

6. A discussion of this intimate relation between space and possibility in Heidegger's late work culminates Casey's chapter "Proceeding to Place by Indirection: Heidegger," in his *Fate of Place*. As Casey writes,

We return at the end to that vista of sheer spatial possibility from which Heidegger had first shrunk back in *Being and Time*. Thirty years later, Heidegger is willing to do what he could not bring himself to do earlier, namely, to "embrace the

sheer possibilities of the pure spatial Being of something" [*SZ* 117; tm]. He can do so inasmuch as he has discovered that this possibilizing spatial Being resides in place—or, more exactly, in the regions that places institute in the course of generating something like space. (283)

We are in agreement with Casey when he concludes that this ultimately amounts to "another way of conceiving Being" apart from the "temporocentrist preoccupation" of *Being and Time* (284, 256).

7. "Das Rektorat 1933 /1934: Tatsachen und Gedanken," in Heidegger, *Selbstbehauptung*, 29 /21.

8. Heidegger, *Selbstbehauptung*, 30 /22; tm.

9. Heidegger, *Selbstbehauptung*, 30 /22; tm.

10. In the opening pages of his Rilke interpretation, Heidegger brings together the Hölderlinian thought of the abyss as "all marking" with the gesture of the mortals in Rilke's poetry, mortals who themselves "reach further into the abyss," offering more of themselves to that abyss for its marking (see *GA* 5: 269–71 /200–202). This reaching that marks, but is itself marked in turn (marking *as* reaching, marking as touch), is the sculptural gesture *in nuce*.

11. Heidegger will also speak of it in terms of a glance of the god in a 1964 letter on the problem of a "nonobjectifying thinking and speaking" in contemporary theology: "The statue of Apollo in the museum at Olympia we can indeed regard as an object of natural-scientific representation; we can calculate the physical weight of the marble; we can investigate its chemical composition. But this objectifying thinking and speaking does not catch sight of [erblickt nicht] the Apollo who shows forth his beauty and so appears as the glance [Anblick des Gottes] of the god" (*GA* 9: 73–74 /58; tm).

12. Relationality is also operative in Heidegger's 1960 assessment of sculpture, as recorded by Dino Larese. At the 1960 gallery opening for the sculptor Giacomo Manzú, Larese asked Heidegger about his impression of the sculptures: "In his halting manner of deliberately setting down his words he said: 'A very simple answer can be given to your question. It is the immediacy of the sculptural presentation, in which for me something originary from Greek sculpture again comes to appearance, without being able to be construed as an imitation. In this art I see a new attempt to realize once again what I regard to be the essence of art, the setting-into-the-work of

truth—in the manner of once again bringing the image of the human and of human relationships into a presentation'" (Larese, *Mit Heidegger in Hauptwil*, 6).

13. As reported in Wellmann, *Die Köpfe*, 118. See also the letter to Elfride from 4 October 1964: "Yesterday afternoon was the opening of the exhibition for the members of the Berlin Academy [of the Fine Arts]. Heiliger, the most distinguished of them, modeled me in clay for two hours in the morning at the request of the Lareses; he has made heads of Heuß, Reuter & Chairman Martin; it was astonishing how he worked in that short period of time; today I have to sit once again" (*MLS* 353 /290–91; tm). In 1965, with Erker-Presse, Heiliger also printed a limited edition lithograph of Heidegger in profile (two hundred copies signed by each), a reproduction of which is more widely available as the cover illustration to Petzet's *Auf einen Stern zugehen*.

14. Letter reproduced in *BH* 18. A transcription of the letter appeared in the retrospective catalog *Die Köpfe*, though this transcription omits the adjective "earthly" from "earthly heaven" in the letter (Wellmann, *Die Köpfe*, 118). An earlier partial transcription appeared in Jähnig's "'Der Ursprung des Kunstwerkes'" (236) with an apparent misreading of "verhüllten irdischen Himmel" as "erfüllten irdischen Himmel." I am grateful to Peter Trawny for his assistance in deciphering Heidegger's Sütterlin script.

Chapter 3. Excursus on the Goddess Athena

1. On the floating of figures in relief and the nonrhythmic space that they require, see Adrian Stokes's chapter "Carving, Modelling, and Agostino," in *Stones of Rimini*, 105–66, esp. 154.

2. Sallis fruitfully understands Athena *die Sinnende* as "the one who senses, who, watching and considering, exemplifies in her activity the double sense of sense, even if dissolving the distinction in the unity of her activity" (*Stone*, 96–97). The double sense of sense is its simultaneous physical (sensual) and intellectual /meaningful (sensible) dimension, as he explains: "In itself the word *sense* houses the most gigantic ambivalence, indifferently coupling the difference between what is called the sensible, things of sense apprehended perceptually, *and* signification, meaning, a signified or intended sense" (13). In many respects, the present work is an exploration of that doubled sense.

3. See *GA* 45: 177–80 /153–55, on the relation between *physis* and *techne*.

Chapter 4: Eduardo Chillida

1. Chillida gives his account of the meeting and events leading up to it in Ugalde, *Hablando con Chillida*, 104–6. This book-length interview includes the sculptor's most detailed discussion of his collaboration with Heidegger, see especially 104–14. Chillida notes that Heidegger already knew his work (along with the sculptures of Chillida, Heidegger had been studying those of Moore and Giacometti), and that their meeting at the Erker-Galerie in St. Gallen in 1968 was easy for Heidegger because he was frequently in Zurich for his seminars with Medard Boss. It is worth noting that, along with the sculptural texts, these Zollikon seminars are crucial works for understanding Heidegger's conception of the body in his later thought.

2. Malpas recognizes this as a point of difference between the account of place given in "Building Dwelling Thinking." He writes, "In 'Art and Space,' the emphasis is on the settled locality—*'die Ortschaft'*—rather than the solitary place, and on the belonging together of things, rather than on the gathering that occurs in the single thing. In this way, the account that is suggested in 'Art and Space' contains an important recognition of the way in which places themselves always implicate, and are implicated by, other such places" (Malpas, *Heidegger's Topology*, 263).

3. Volboudt, *Chillida*, viii–ix.

4. Something that Chillida himself appears to have explicitly realized. In a 1990 interview, the sculptor describes a change in his views of form, the realization that form itself alters the space through which it reverberates: "A few years ago I realized that looking through a window, for example a Romanesque window in a church, if you are inside the church and you look through the window, you have projected the form of the window into the space outside, in the infinite space outside. And then I had suddenly the feeling that this projection of the space concerned with the form had a different density to the rest of the space" (South Bank Centre, *Chillida*, 39).

5. Ugalde, *Hablando con Chillida*, 107.

6. The phrase *spacing out* is strangely appropriate here, even given its informal connotation, insofar as this refer to a lack of concentration. What is "spaced out" is diffused across and beyond itself.

7. Crowther, "Space, Place, and Sculpture," rightly (if perhaps even alone in the literature) emphasizes the role of relationality in "Art and Space." When he writes that

Heidegger's linking of sculpture to place "must find ways of emphasizing the mutual dependence of place's elemental and relational aspects" (161), it is hoped that the reflections of this chapter go part of the way toward accomplishing this.

8. In his essay "Assemblages: In Praise of Chillida," Beistegui speaks of this "gathering" character of Chillida's work in terms of an assembling: "To assemble means not only to fit or put together the parts of some artifact, to adjust them, often with a view to supporting or sustaining something else . . . , but also to gather, to collect" (335–36). This give-and-take of assembly is operative between work and world as well. His essay concludes with the thought that "that which the work presents and sustains, the very forces that bring it into presence, aren't just the forces that sustain this or that work, but the world as such and as a whole. . . . Ultimately, the assembling presented in the works is assembling or adjusting as such, that is, assembling as the universal law of poetic nature. It designates the state of equilibrium or reconciliation that gathers within it the most extreme tension" (336). Gathering is always and at the same time divestment into relation.

9. Petzet also mentions "Aeolian Harp Made of Iron" in this context, though this is the title of a sculpture by Heiliger, not Chillida.

10. A point noted by Octavio Paz in "Chillida: From Iron to Light," where he writes, "When he returned to his land, Chillida returned to the antiquity of his race and to the two elements that epitomize the Basque character: fire and iron. . . . The forges of the Basque country have been famous since the days of the Romans. . . . His attitude to iron and other metals, and the way he works and treats them, carry on the tradition of the iron-workers and blacksmiths of his people" (11–12). Chillida himself confirms the point in discussing his turn to ironworking: "In this I was resuming contact with an age-old inheritance" (Volboudt, *Chillida*, x).

11. Held, "Zur Bestimmung zeitgenössischer Plastik," 111.

12. One of Chillida's drawings, *Herramientas* (Tools), consists of the outlines to a number of metalworking tools. Reproduced in de Barañano, *Elogio del Hierro*, 28.

13. There are at least sixteen of these pieces, constructed between 1954 and 1966. One should also consider in this context the numerous drawings that Chillida made in the later part of this period where the subject matter is precisely hands in the act of drawing.

14. This emphasis on things is also found in the dedication that Heidegger inscribed on stone at the Erker-Galerie event:

> The following considerations are concerned with the riddle of art, the riddle that art itself is. They are far from the claim of solving this riddle. The task consists in seeing the riddle.
>
> From time to time we still have the feeling that violence has long been done to the thingliness of things and that thinking would play a role in this violence, for which reason one swears off thinking, instead of taking the trouble to make thinking more thoughtful.
>
> For Eduardo Chillida
>
> St. Gallen, 24 November 1968
>
> Martin Heidegger

(*GA* 16: 696; cf. *GA* 5: 67/50, 9/7)

For a reproduction of the actual tablet with Heidegger's inscription, see Semff, *Chillida*, 12.

15. On this point, it is also worth noting that Chillida does not work with models ("That is why I never make rough models. I never work on anything but the actual sculpture. The work is its own model and corrects itself as I work on it"; Volboudt, *Chillida*, viii).

16. Unfortunately, the year of composition cannot be specified further than between 1960, the year of its publication, and 1976, the year of Heidegger's death (see *GA* 5: 380/288–289). Nevertheless, Heidegger does not seem terribly adamant about the alteration. In one of the meetings organized by Larese at the Erker-Galerie bringing together well-known authors and artists, Erker Treffen I, held in 1972, Heidegger contributed a phrase similar to the one from "The Origin of the Work of Art" on lithographic stone to accompany a print by the Italian artist Giuseppe Santomaso: "The essence of art is the setting-itself-into-the-work of truth."

17. Ugalde, *Hablando con Chillida*, 110.

18. Dempsey, *Sculptors Talking*, 45.

19. Ugalde, *Hablando con Chillida*, 110.

20. Ibid.

21. As reported by Erhart Kästner in his speech at the opening of the *Die Kunst und*

der Raum gallery event, "Rede bei der Hinausgabe des Buches von Martin Heidegger und Eduardo Chillida: *Die Kunst und der Raum*; Galerie im Erker in Sankt Gallen am 12. Oktober 1969" (Speech at the Reception for the Book by Martin Heidegger and Eduardo Chillida: *Art and Space*; Erker-Galerie in St. Gallen on 12 October 1969) in Kästner, *Offener Brief,* 46. The original publication of Kästner's speech (*Martin Heidegger/ Eduardo Chillida*) was accompanied by another lithocollage from Chillida, "Hommage à Heidegger" (Homage to Heidegger; for a reproduction see van der Koelen, *Werkverzeichnis der Druckgraphik,* 248–49).

22. In his interview with Ugalde, Chillida mentions how he was struck by Heidegger's approach to communicating with him at their first meeting. Their conversation shifted between French, English (!), and Spanish, "but he answered me in German so a student of his, Espinosa, could translate for me, because I do not speak German" (Ugalde, *Hablando con Chillida,* 104–5). Chillida was struck by the fact that Heidegger preferred to give way to a translator /mediator than to make do with shared imperfect languages, leading him to comment that the proper entry into a shared space requires that we adhere to what is most our own, "we have to arrive with our own" (111).

23. Dempsey, *Sculptors Talking,* 56.

24. Chillida and Wagner, "Interview," 25. The ensuing remarks show that this horizon is also a site of contact and interface: "I wanted to do an homage to the horizon and it had been an idea for some time. However, elements of the horizon cannot be measured, so Pili (my wife) and I traveled the Atlantic coast from Brittany to Compostela. We discovered that we always encountered the military, because the coast is an access point that always needed protection. The coast is a place where one can see great distances and the horizon is great" (25).

25. It is precisely against Ernst Jünger, whose figure of the *Waldgänger* (forest goer) would take up an adventurous residence in the beyond of the forest, that Heidegger proposes a "garden of the wilderness [Garten der Wildnis] in which growth and care [Pflege] are attuned to one another out of an incomprehensible intimacy [Innigkeit]" (see *GA* 9: 423–24 /320). As always maintaining a relation to us, the wilderness is ever as intimate as a garden.

26. Volboudt, *Chillida,* xi.

27. "Let us try to listen to language. Whereof does it speak in the word 'space'?"

(*GA* 13: 206 /*AS* 5; tm), the discussion of "spacing" follows. Later, Heidegger puzzles over the nature of emptiness, "Again, language can give us a hint" (*GA* 13: 209 /*AS* 7), a connection between emptying (*leeren*) and gathering (*lesen*) follows.

28. This could be seen as the corporealization of a familiar notion from *Being and Time*. When I hear something, I never hear raw sound, I hear, instead, the motorcycle outside (see *BT* para. 34). What appears does so meaningfully. Rather than view this as an attribute of the subject, who has always already interpreted experience, Heidegger attributes this to the understanding of Dasein. But since Dasein is so inextricably stitched into the world, that understanding pervades all appearing and is no possession of Dasein. Dasein stands in no particular privilege to this understanding; we might say it is not its possessor. Instead Dasein as mortal participates in the sensible appearing of things.

29. Among other places, cf. "Language" (*GA* 12: 18 /*PLT* 198) and "The Poem" (*GA* 4: 188 /215).

Conclusion

1. See the opening of Heidegger's second Trakl interpretation, "Language in the Poem: A Discussion on Georg Trakl's Poetic Work" (*GA* 12: 33–35 /*OWL* 159–61). Similar allusions to the ebb and flow of existence can be detected in Heidegger's thinking at the time of the *Beiträge* (see esp. §§ 238–42 on time-space; *GA* 65: 371–88 /259–71). There, Heidegger speaks of the charming and evasive relation to the withdrawal of being that he identifies in terms of *Berücken* and *Entrücken*. The trembling and swaying of being itself should also be thought in terms of mediality.

Bibliography

Texts by Martin Heidegger in the *Gesamtausgabe*
(Frankfurt am Main: Vittorio Klostermann, 1976–)

Aus der Erfahrung des Denkens (From the Experience of Thinking). *Gesamtausgabe*, vol. 13. Ed. Hermann Heidegger, 1983.

Beiträge zur Philosophie (vom Ereignis). 2nd ed. *Gesamtausgabe*, vol. 65. Ed. Friedrich-Wilhelm von Herrmann, 1994. Translated as *Contributions to Philosophy (from Enowning)*. Trans. Parvis Emad and Kenneth Maly. Bloomington: Indiana University Press, 1999.

Bremer und Freiburger Vorträge: 1. Einblick in das was ist; 2. Grundsätze des Denkens (Bremen and Freiburg Lectures: 1. Insight into That Which Is; 2. Basic Principles of Thinking). *Gesamtausgabe*, vol. 79. Ed. Petra Jaeger, 1994.

Erläuterungen zu Hölderlins Dichtung. 2nd ed. *Gesamtausgabe*, vol. 4. Ed. Friedrich-Wilhelm von Herrmann, 1996. Translated as *Elucidations of Hölderlin's Poetry*. Trans. Keith Hoeller. Amherst, NY: Humanity Books, 2000.

Grundfragen der Philosophie: Ausgewählte "Probleme" der "Logik." 2nd ed. *Gesamtausgabe*, vol. 45. Ed. Friedrich-Wilhelm von Herrmann, 1992. Translated as *Basic Questions of Philosophy: Selected "Problems" of "Logic."* Trans. Richard Rojcewicz and André Schuwer. Bloomington: Indiana University Press, 1994.

Die Grundprobleme der Phänomenologie. 2nd ed. *Gesamtausgabe*, vol. 24. Ed. Friedrich-Wilhelm von Herrmann, 1989. Translated as *The Basic Problems of Phenomenology* Rev. ed. Trans. Albert Hofstadter. Bloomington: Indiana University Press, 1982.

Holzwege. 2nd ed. *Gesamtausgabe*, vol. 5. Ed. Friedrich-Wilhelm von Herrmann, 2003. Translated as *Off the Beaten Track*. Trans. Julian Young and Kenneth Haynes. Cambridge: Cambridge University Press, 2002.

Kant und das Problem der Metaphysik. *Gesamtausgabe*, vol. 3. Ed. Friedrich-Wilhelm von Herrmann, 1991. Translated as *Kant and the Problem of Metaphysics*. Trans. Richard Taft. 5th enlarged ed. Bloomington: Indiana University Press, 1997.

Metaphysik und Nihilismus: 1. Die Überwindung der Metaphysik; 2. Das Wesen des Nihilismus (Metaphysics and Nihilism: 1. The Overcoming of Metaphysics; 2. The Essence of Nihilism). *Gesamtausgabe*, vol. 67. Ed. Hans-Joachim Friedrich, 1999.

Metaphysische Anfangsgründe der Logik. 3rd ed. *Gesamtausgabe*, vol. 26. Ed. Klaus Held,

2007. Translated as *The Metaphysical Foundations of Logic*. Trans. Michael Heim. Bloomington: Indiana University Press, 1992.

Reden und andere Zeugnisse eines Lebensweges (Speeches and Other Testaments to a Life's Journey). *Gesamtausgabe*, vol. 16. Ed. Friedrich-Wilhelm von Herrmann, 2000.

Seminare (Seminars). *Gesamtausgabe*, vol. 15. Ed. Curd Ochwadt, 1986.

Unterwegs zur Sprache (On the Way to Language). *Gesamtausgabe*, vol. 12. Ed. Friedrich-Wilhelm von Herrmann, 1985.

Vorträge und Aufsätze (Lectures and Essays). *Gesamtausgabe*, vol. 7. Ed. Friedrich-Wilhelm von Herrmann, 2000.

Wegmarken. 2nd ed. *Gesamtausgabe*, vol. 9. Ed. Friedrich-Wilhelm von Herrmann, 1996. Translated as *Pathmarks*. Ed. William McNeill. Trans. various. Cambridge: Cambridge University Press, 1998.

Martin Heidegger in Single Editions

Bemerkungen zu Kunst—Plastik—Raum (Remarks on Art—Sculpture—Space). Ed. Hermann Heidegger. St. Gallen, Switzerland: Erker Verlag, 1996.

"Die Herkunft der Kunst und die Bestimmung des Denkens" (The Provenance of Art and the Determination of Thinking). In *Distanz und Nähe: Reflexionen und Analysen zur Kunst der Gegenwart*, ed. Petra Jaeger and Rudolf Lüthe, 11–22. Würzburg: Verlag Königshausen und Neumann, 1983.

Die Kunst und der Raum. 2nd ed. St. Gallen, Switzerland: Erker Verlag, 1983.

"Mein liebes Seelchen!" Briefe Martin Heideggers an seine Frau Elfride, 1915–1970. Ed. Gertrud Heidegger. Munich: Deutsche Verlags-Anstalt, 2005. Translated as *Letters to His Wife, 1915–1970*. Trans. R. D. V. Glasgow. Cambridge: Polity Press, 2008.

Sein und Zeit. 17th ed. Tübingen: Max Niemeyer Verlag, 1993. Translated as *Being and Time*. Trans. John Macquarrie and Edward Robinson. San Francisco: Harper and Row, 1962.

Die Selbstbehauptung der deutschen Universität: Das Rektorat, 1933/34. 2nd ed. Ed. Hermann Heidegger. Frankfurt am Main: Vittorio Klostermann, 1990. Translation in *Martin Heidegger and National Socialism: Questions and Answers*, ed. Günther Neske and Emil Kettering, trans. Lisa Harries with Joachim Neugroschel, 3–32. New York: Paragon House, 1990.

Martin Heidegger in English Translation Single Editions

"Art and Space." Trans. Charles H. Seibert. *Man and World* 6, no. 1 (February 1973): 3–8.

The End of Philosophy. Ed. and trans. Joan Stambaugh. New York: Harper and Row, 1973.

Four Seminars. Trans. Andrew J. Mitchell and François Raffoul. Bloomington: Indiana University Press, 2003.

On the Way to Language. Ed. and trans. Peter D. Herz. San Francisco: Harper and Row, 1971.

Poetry, Language, Thought. Ed. and trans. Albert Hofstadter. New York: Harper and Row, 1971.

Texts by Other Authors

Barañano, Kosme de, ed. *Eduardo Chillida: Elogio del Hierro; In Praise of Iron.* Valencia, Spain: Institut Valencià d'Art Modern, 2002.

Barlach, Ernst. *Das dichterische Werk* (The Poetic Work). 3 vols. Ed. Friedrich Droß. Vols. 2 and 3, *Die Prosa I* and *Die Prosa II* (Prose I and Prose II). Munich: R. Piper Verlag, 1958, 1959.

———. *Leben und Werk in seinen Briefen* (Life and Work in His Letters). Ed. Friedrich Droß. Munich: R. Piper Verlag, 1952.

Baron, Stephanie, ed. *"Degenerate Art": The Fate of the Avant-Garde in Nazi Germany.* Los Angeles: Los Angeles County Museum of Art, 1991.

Beistegui, Miguel de. "Assemblages: In Praise of Chillida." *Internationales Jahrbuch für Hermeneutik* 7 (2008): 317–37.

Beloubek-Hammer, Anita. *Ernst Barlach: Plastische Meisterwerke.* (Ernst Barlack: Sculptural Masterworks) Leipzig: Seemann, 1996.

Biemel, Walter, and Friedrich-Wilhelm von Herrmann, ed. *Kunst und Technik: Gedächtnisschrift zum 100. Geburtstag von Martin Heidegger* (Art and Technology: Commemorations on the 100th Birthday of Martin Heidegger). Frankfurt am Main: Vittorio Klostermann, 1989.

Casey, Edward S. *The Fate of Place: A Philosophical History.* Berkeley: University of California Press, 1997.

Chillida, Eduardo, and Sandra Wagner. "An Interview with Eduardo Chillida." *Sculpture* 16, no. 9 (November 1997): 22–27.

Crowther, Paul. "Space, Place, and Sculpture: Working with Heidegger." *Continental Philosophy Review* 40 (2007): 151–70.

Dempsey, Andrew, ed. *Sculptors Talking: Anthony Caro, Eduardo Chillida.* New York: Art of This Century, 2000.

Derrida, Jacques. "Geschlecht I: Sexual Difference, Ontological Difference." Trans. Ruben Bevezdivin and Elizabeth Rottenberg. In Jacques Derrida, *Psyche,* vol. 2, ed. Peggy Kamuf and Elizabeth Rottenberg, 7–26. Stanford, Calif.: Stanford University Press, 2008.

Dresler, Adolf. *Deutsche Kunst und Entartete Kunst: Kunstwerk und Zerrbild als Spiegel der Weltanschauung* (German Art and Degenerate Art: Artwork and Distortion as Mirror of a Worldview). Munich: Deutscher Volksverlag, 1938.

Elden, Stuart. *Mapping the Present: Heidegger, Foucault, and the Project of a Spatial History.* New York: Continuum, 2001.

Gross, Helmut. *Zur Seinserfahrung bei Ernst Barlach: Eine ontologische Untersuchung von Barlachs dichterischem und bildnerischem Werk* (On the Experience of Being in Ernst Barlach: An Ontological Investigation of Barlach's Poetic and Figurative Work). Freiburg im Breisgau: Verlag Herder, 1967.

Held, Jutta. "Zur Bestimmung zeitgenössischer Plastik durch Chillida und Heidegger" (On the Determination of Contemporary Sculpture by Chillida and Heidegger). *Jahrbuch der Hamburger Kunstsammlungen* 20 (1975): 103–26.

Jäeger Petra, and Rudolf Lüthe, ed. *Distanz und Nähe: Reflexionen und Analysen zur Kunst der Gegenwart* (Distance and Nearness: Reflections and Analyses of the Art of the Present). Würzburg: Verlag Dr. Johannes Königshausen und Dr. Thomas Neumann, 1983.

Jähnig, Dieter. "'Der Ursprung des Kunstwerkes' und die moderne Kunst" ("The Origin of the Work of Art" and Modern Art). In *Kunst und Technik: Gedächtnisschrift zum 100. Geburtstag von Martin Heidegger,* ed. Walter Biemel and Friedrich-Wilhelm von Herrmann, 219–54. Frankfurt am Main: Vittorio Klostermann, 1989.

Kaiser, Fritz. *Entartete "Kunst": Ausstellungsführer* (Degenerate "Art": Guide to the Exhibition). Berlin: Verlag für Kultur- und Wirtschaftswerbung, 1937. Translated as "Facsimile of the 'Entartete Kunst' Exhibition Broschure," trans. David Britt, in *"Degenerate Art": The Fate of the Avant-Garde in Nazi Germany,* ed. Stephanie Baron, 356–90. Los Angeles: Los Angeles County Museum of Art, 1991.

Kästner, Erhart. *Martin Heidegger/Eduardo Chillida—Die Kunst und der Raum* (Martin Heidegger /Eduardo Chillida—Art and Space). St. Gallen, Switzerland: Erker Verlag, 1970.

———. *Offener Brief an die Königin von Griechenland: Beschreibungen, Bewunderungen* (An Open Letter to the Queen of Greece: Descriptions, Admirations). Frankfurt am Main: Suhrkamp Verlag, 1973.

Kockelmans, Joseph J. *Heidegger on Art and Art Works.* Dordrecht: Martinus Nijhoff, 1985.

Kulturverwaltung der Stadt Darmstadt, ed. *Ernst Barlach: Dramatiker, Bildhauer, Zeichner* (Ernst Barlach: Dramatist, Sculptor, Draughtsman). Darmstadt: Verlag von Eduard Stichnote, 1951.

Larese, Dino. *Mit Heidegger in Hauptwil* (With Heidegger in Hauptwil). Amriswil, Switzerland: Amriswiler Bücherei, 1960.

———, ed. *Philosophen am Bodensee* (Philosophers at Lake Constance). Friedrichshafen, Germany: Verlag Robert Gessler, 1999.

Larese, Franz, and Jürg Janett, eds. *Bernhard Heiliger.* Erker-Galerie, 3 October to 7 November 1964. St. Gallen, Switzerland: Erker-Presse, 1964.

Malpas, Jeff. *Heidegger's Topology: Being, Place, World.* Cambridge: MIT Press, 2006.

Michelin, Gisèle. *Chillida.* Pittsburgh International Series, Museum of Art. Carnegie Institute. Paris: Maeght Éditeur, 1979.

Neske, Günther, and Emil Kettering, ed. *Martin Heidegger and National Socialism: Questions and Answers.* Trans. Lisa Harries with Joachim Neugroschel. New York: Paragon House, 1990.

Paret, Peter. *An Artist Against the Third Reich: Ernst Barlach, 1933–1938.* Cambridge: Cambridge University Press, 2003.

Petzet, Heinrich Wiegand. *Auf einen Stern zugehen: Begegnungen und Gespräche mit Martin Heidegger, 1929–1976.* Frankfurt am Main: Societäts-Verlag, 1983. Translated as *Encounters and Dialogues with Martin Heidegger, 1929–1976.* Trans. Parvis Emad and Kenneth Maly. Chicago: University of Chicago Press, 1993.

Paz, Octavio. "Chillida: From Iron to Light." In *Chillida,* by Gisèle Michelin, 8–18. Pittsburgh International Series, Museum of Art. Carnegie Institute. Paris: Maeght Éditeur, 1979.

Piper, Ernst. *Ernst Barlach und die nationalsozialistische Kunstpolitik: Eine dokumentarische Darstellung zur "entarteten Kunst"* (Ernst Barlach and the National-Socialist Politics of Art: A Documentary Presentation on "Degenerate Art"). Munich: R. Piper Verlag, 1983.

Rilke, Rainer Maria. *The Selected Poetry of Rainer Maria Rilke*. Trans. Stephen Mitchell. New York: Vintage International, 1989.

Sallis, John. *Stone*. Bloomington: Indiana University Press, 1994.

Schalow, Frank. *The Incarnality of Being: The Earth, Animals, and the Body in Heidegger's Thought*. Albany: State University of New York Press, 2006.

Selz, Peter. *Chillida*. New York: Harry N. Abrams, 1986.

Semff, Michael, ed. *Chillida*. Pforzheim, Germany: Stadt Pforzheim, 1987.

Seubold, Günter. *Kunst als Enteignis: Heideggers Weg zu Einer Nicht Mehr Metaphysichen Kunst* (Art as Disappropriation: Heidegger's Path to a Nonmetaphysical Art). Bonn: Bouvier Verlag, 1996.

South Bank Centre, ed. *Chillida*. Hayward Gallery, London. 6 September–4 November 1990. Vitoria, Spain: Eraclio Fournier, 1990.

Stokes, Adrian. *Stones of Rimini*. University Park: Pennsylvania State University Press, 2002.

Strehler, Hermann, ed. *Dino Larese zum 50. Geburtstag am 26. August 1964* (Dino Larese for His 50th Birthday on 26 August 1964). St. Gallen, Switzerland: Zollikofer, 1964.

———, ed. *Dino Larese zum 60. Geburtstag am 26. August 1974* (Dino Larese for His 60th Birthday on 26 August 1974). St. Gallen, Switzerland: Zollikofer, 1974.

Stubbe, Wolf, ed. *Ernst Barlach: Plastik* (Ernst Barlach: Sculpture). Munich: R. Piper Verlag, 1959.

Tank, Kurt Lothar. *Deutsche Plastik unserer Zeit* (German Sculpture of Our Time). Ed. Wilfrid Bade. Munich: Raumbild-Verlag Otto Schönstein, 1942.

Ugalde, Martín de. *Hablando con Chillida, Escultor Vasco* (Speaking with Chillida, Basque Sculptor). San Sebastian: Editorial Txertoa, 1975.

Vallega, Alejandro A. *Heidegger and the Issue of Space: Thinking on Exilic Ground*. University Park: Pennsylvania State University Press, 2003.

van der Koelen, Dorothea, ed. *Eduardo Chillida—Opus P. I. Werkverzeichnis der Druck-*

graphik, 1959–1972 (Eduardo Chillida—Opus Part I: Catalog Raisonné of the Graphic Prints). Mainz: Chorus-Verlag, 1999.

Volboudt, Pierre. *Chillida.* Trans. Vivienne Menkes. New York: Harry N. Abrams, 1967.

Wellmann, Marc, ed. *Bernhard Heiliger, 1915–1995: Monographie und Werkverzeichnis* (Bernhard Heiliger, 1915–1995: Monograph and Catalog Raisonné). Köln: Wienand Verlag, 2005.

———, ed. *Bernhard Heiliger: Die Köpfe* (Bernhard Heiliger: The Heads). Köln: Wienand Verlag, 2000.

Young, Julian. *Heidegger's Philosophy of Art.* Cambridge: Cambridge University Press, 2004.